Francis Frith's
Amersham, Chesham & Rickmansworth

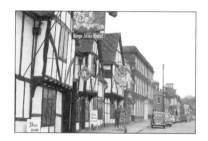

Photographic Memories

Francis Frith's
Amersham, Chesham
& Rickmansworth

Martin Andrew

First published in the United Kingdom in 2001 by
Frith Book Company Ltd

Paperback Edition 2001
ISBN 1-85937-340-2

British Library Cataloguing in Publication Data

Francis Frith's Amersham, Chesham & Rickmansworth
Martin Andrew

Frith Book Company Ltd
Frith's Barn, Teffont,
Salisbury, Wiltshire SP3 5QP
Tel: +44 (0) 1722 716 376
Email: info@francisfrith.co.uk
www.francisfrith.co.uk

Printed and bound in Great Britain

Front Cover: Chesham, The Market Place 1897 40536

AS WITH ANY HISTORICAL DATABASE THE FRITH ARCHIVE IS CONSTANTLY BEING CORRECTED AND IMPROVED
AND THE PUBLISHERS WOULD WELCOME INFORMATION ON OMISSIONS OR INACCURACIES

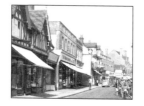

Contents

Francis Frith: *Victorian Pioneer*

FRANCIS FRITH, Victorian founder of the world-famous photographic archive, was a complex and multi-talented man. A devout Quaker and a highly successful Victorian businessman, he was both philosophic by nature and pioneering in outlook.

By 1855 Francis Frith had already established a wholesale grocery business in Liverpool, and sold it for the astonishing sum of £200,000, which is the equivalent today of over £15,000,000. Now a multi-millionaire, he was able to indulge his passion for travel. As a child he had pored over travel books written by early explorers, and his fancy and imagination had been stirred by family holidays to the sublime mountain regions of Wales and Scotland. 'What a land of spirit-stirring and enriching scenes and places!' he had written. He was to return to these scenes of grandeur in later years to 'recapture the thousands of vivid and tender memories', but with a different purpose. Now in his thirties, and captivated by the new science of photography, Frith set out on a series of pioneering journeys to the Nile regions that occupied him from 1856 until 1860.

Intrigue and Adventure

He took with him on his travels a specially-designed wicker carriage that acted as both dark-room and sleeping chamber. These far-flung journeys were packed with intrigue and adventure. In his life story, written when he was sixty-three, Frith tells of being held captive by bandits, and of fighting 'an awful midnight battle to the very point of surrender with a deadly pack of hungry, wild dogs'. Sporting flowing Arab costume, Frith arrived at Akaba by camel seventy years before Lawrence, where he encountered 'desert princes and rival sheikhs, blazing with jewel-hilted swords'.

During these extraordinary adventures he was assiduously exploring the desert regions bordering the Nile and patiently recording the antiquities and peoples with his camera. He was the first photographer to venture beyond the sixth cataract. Africa was still the mysterious 'Dark Continent', and Stanley and Livingstone's historic meeting was a decade into the future. The conditions for picture taking confound belief. He laboured for hours in his wicker dark-room in the sweltering heat of the desert, while the volatile chemicals fizzed dangerously in their trays. Often he was forced to work in remote tombs and caves where conditions were cooler. Back in London he exhibited his photographs and was 'rapturously cheered' by members of the Royal Society. His reputation as a

photographer was made overnight. An eminent modern historian has likened their impact on the population of the time to that on our own generation of the first photographs taken on the surface of the moon.

Venture of a Life-Time

Characteristically, Frith quickly spotted the opportunity to create a new business as a specialist publisher of photographs. He lived in an era of immense and sometimes violent change. For the poor in the early part of Victoria's reign work was a drudge and the hours long, and people had precious little free time to enjoy themselves. Most had no transport other than a cart or gig at their disposal, and had not travelled far beyond the boundaries of their own town or village. However,

by the 1870s, the railways had threaded their way across the country, and Bank Holidays and half-day Saturdays had been made obligatory by Act of Parliament. All of a sudden the ordinary working man and his family were able to enjoy days out and see a little more of the world.

With characteristic business acumen, Francis Frith foresaw that these new tourists would enjoy having souvenirs to commemorate their days out. In 1860 he married Mary Ann Rosling and set out with the intention of photographing every city, town and village in Britain. For the next thirty years he travelled the country by train and by pony and trap, producing fine photographs of seaside resorts and beauty spots that were keenly bought by millions of Victorians. These prints were painstakingly pasted into family albums and pored over during the dark nights of winter, rekindling precious memories of summer excursions.

The Rise of Frith & Co

Frith's studio was soon supplying retail shops all over the country. To meet the demand he gathered about him a small team of photographers, and published the work of independent artist-photographers of the calibre of Roger Fenton and Francis Bedford. In order to gain some understanding of the scale of Frith's business one only has to look at the catalogue issued by Frith & Co in 1886: it runs to some 670 pages, listing not only many thousands of views of the British Isles but also many photographs of most European countries, and China, Japan, the USA and Canada – note the sample page shown above from the hand-written *Frith & Co* ledgers detailing pictures taken. By 1890 Frith had created the greatest specialist photographic publishing company in the world,

Frith's death, a new card measuring 5.5 x 3.5 inches became the standard format, but it was not until 1902 that the divided back came into being, with address and message on one face and a full-size illustration on the other. *Frith & Co* were in the vanguard of postcard development, and Frith's sons Eustace and Cyril continued their father's monumental task, expanding the number of views offered to the public and recording more and more places in Britain, as the coasts and countryside were opened up to mass travel.

Francis Frith died in 1898 at his villa in Cannes, his great project still growing. The archive he created continued in business for another seventy years. By 1970 it contained over a third of a million pictures of 7,000 cities, towns and villages. The massive photographic record Frith has left to us stands as a living monument to a special and very remarkable man.

with over 2,000 outlets – more than the combined number that Boots and WH Smith have today! The picture on the right shows the *Frith & Co* display board at Ingleton in the Yorkshire Dales. Beautifully constructed with mahogany frame and gilt inserts, it could display up to a dozen local scenes.

Postcard Bonanza

The ever-popular holiday postcard we know today took many years to develop. In 1870 the Post Office issued the first plain cards, with a pre-printed stamp on one face. In 1894 they allowed other publishers' cards to be sent through the mail with an attached adhesive halfpenny stamp. Demand grew rapidly, and in 1895 a new size of postcard was permitted called the court card, but there was little room for illustration. In 1899, a year after

Frith's Archive: *A Unique Legacy*

FRANCIS FRITH'S legacy to us today is of immense significance and value, for the magnificent archive of evocative photographs he created provides a unique record of change in 7,000 cities, towns and villages throughout Britain over a century and more. Frith and his fellow studio photographers revisited locations many times down the years to update their views, compiling for us an enthralling and colourful pageant of British life and character.

We tend to think of Frith's sepia views of Britain as nostalgic, for most of us use them to conjure up memories of places in our own lives with which we have family associations. It often makes us forget that to Francis Frith they were records of daily life as it was actually being lived in the cities, towns and villages of his day. The Victorian age was one of great and often bewildering change for ordinary people, and though the pictures evoke an impression of slower times, life was as busy and hectic as it is today.

We are fortunate that Frith was a photographer of the people, dedicated to recording the minutiae of everyday life. For it is this sheer wealth of visual data, the painstaking chronicle of changes in dress, transport, street layouts, buildings, housing, engineering and landscape that captivates us so much today. His remarkable images offer us a powerful link with the past and with the lives of our ancestors.

Today's Technology

Computers have now made it possible for Frith's many thousands of images to be accessed almost instantly. In the Frith archive today, each photograph is carefully 'digitised' then stored on a CD Rom. Frith archivists can locate a single photograph amongst thousands within seconds. Views can be catalogued and sorted under a variety of categories of place and content to the immediate benefit of researchers.

Inexpensive reference prints can be created for them at the touch of a mouse button, and a wide range of books and other printed materials assembled and published for a wider, more general readership - in the next twelve months over a hundred Frith local history titles will be published! The day-to-day workings of the archive are very different from how they were in Francis Frith's time: imagine the herculean task of sorting through eleven tons of glass negatives as Frith had to do to locate a particular sequence of pictures! Yet

See Frith at www. frithbook.co.uk

the archive still prides itself on maintaining the same high standards of excellence laid down by Francis Frith, including the painstaking cataloguing and indexing of every view.

It is curious to reflect on how the internet now allows researchers in America and elsewhere greater instant access to the archive than Frith himself ever enjoyed. Many thousands of individual views can be called up on screen within seconds on one of the Frith internet sites, enabling people living continents away to revisit the streets of their ancestral home town, or view places in Britain where they have enjoyed holidays. Many overseas researchers welcome the chance to view special theme selections, such as transport, sports, costume and ancient monuments.

We are certain that Francis Frith would have heartily approved of these modern developments in imaging techniques, for he himself was always working at the very limits of Victorian photographic technology.

The Value of the Archive Today

Because of the benefits brought by the computer, Frith's images are increasingly studied by social historians, by researchers into genealogy and ancestory, by architects, town planners, and by teachers and schoolchildren involved in local history projects.

In addition, the archive offers every one of us an opportunity to examine the places where we and our families have lived and worked down the years. Highly successful in Frith's own era, the archive is now, a century and more on, entering a new phase of popularity.

The Past in Tune with the Future

Historians consider the Francis Frith Collection to be of prime national importance. It is the only archive of its kind remaining in private ownership and has been valued at a million pounds. However, this figure is now rapidly increasing as digital technology enables more and more people around the world to enjoy its benefits.

Francis Frith's archive is now housed in an historic timber barn in the beautiful village of Teffont in Wiltshire. Its founder would not recognize the archive office as it is today. In place of the many thousands of dusty boxes containing glass plate negatives and an all-pervading odour of photographic chemicals, there are now ranks of computer screens. He would be amazed to watch his images travelling round the world at unimaginable speeds through network and internet lines.

The archive's future is both bright and exciting. Francis Frith, with his unshakeable belief in making photographs available to the greatest number of people, would undoubtedly approve of what is being done today with his lifetime's work. His photographs, depicting our shared past, are now bringing pleasure and enlightenment to millions around the world a century and more after his death.

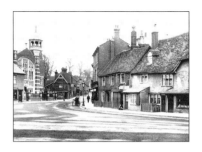

Amersham, Chesham & Rickmansworth
An Introduction

THESE THREE MARKET towns, two in Buckinghamshire and one in Hertfordshire, are in striking contrast to one another. Certainly Amersham is the most visited by tourists as a destination, if one discounts the boats, walkers and cyclists along the Grand Union Canal as it passes immediately south of Rickmansworth. Amersham remains a virtually intact pre-Victorian town, its brick fronts concealing many older timber-framed buildings. Modern development, when it came after 1890, was kept uphill and mostly out of sight of the old town set in the valley. The town is on the River Misbourne, a Chiltern chalk stream that soon turns south to flow through the Chalfonts to join the River Colne at Denham. The other two towns are on the River Chess which starts just beyond Chesham and flows for little more than nine miles before meeting the Colne and the Gade at Rickmansworth.

The towns are given much of their character by their river valley location. However their architectural heritages have been treated very differently. For the most part Amersham has retained its original architectural layout, its long, wide sinuous market-place running from the west end of the High Street, past the superb 1682 Market Hall into what is now called Market Place, and beyond into Broadway. Whielden Street and Church Street are the only north-south roads, the latter a minor one in length terms. All this has been preserved from the pressures of development by the Drake family, later the Tyrwhitt-Drakes, of Shardeloes, the Palladian mansion that sits in its landscaped park west of the town. The family successfully prevented any railway company in the

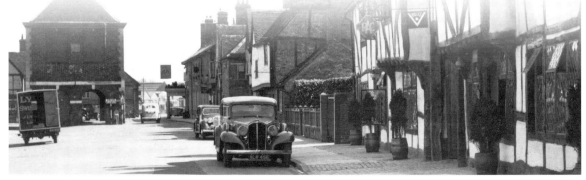

19th century from coming along the valley to disturb their view. The railway was only eventually allowed in the 1890s on a route well north of the town and out of sight of Shardeloes. When development came, accompanying the railway, it was only permitted uphill and hidden from most of the old town and soon named Amersham-on-the-Hill. The cornfields and Parsonage Woods were protected as a cordon sanitaire between old and new. The result was a splendidly conserved town, a town much as it was around 1850. Admittedly there are a few fluffed notes, such as the nurses' home tower, many of the out-of-scale hospital buildings at the south end of Whielden Street and a Tesco's that replaced Wallis Gilbert's 1935 bus garage.

The parish church is a large one and, like Chesham, dedicated to St Mary the Virgin. Both were heavily restored by the Victorians; Amersham in the 1870s and 1880s, and Chesham in the 1860s by Sir George Gilbert Scott. Amersham is mostly 13th and 14th century, but, besides its undoubted townscape value its chief glory is the superb collection of monuments, both those to the Drake family of Shardeloes in the Drake Chapel and those in the chancel and transepts.

Within the town there are numerous high quality houses and buildings and considerable architectural and historic interest. I will pick out a few, the most obvious being the wonderful Market Hall at the High Street and Market Place junction, given by Sir William Drake in 1682. However there are many others including the Tudor style workhouse in Whielden Street designed by the young George Gilbert Scott and Moffat in 1838, a riot of flint and exuberant red brick in zig-zags and diaper patterns. Later the core of Amersham Hospital, it is now converted into flats. Every street holds some architectural interest. There is much exposed timber-framing, such as in the King's Arms and a number of cottages. Other cottages have been refaced in the last 300 years in now mellowed local brick. There are also later rebuilt houses from the Georgian period to the early 19th century which add considerably to the townscape, including Elmodesham house in the High Street, part 1720s brick, partly Edwardian enlargement. But the majority of houses fronting the streets belie their brick facades and conceal timber-framing from the 16th and 17th centuries, including the tall Griffin Inn in the Broadway, now an ASK pizza restaurant, and the stucco-fronted Red Lion House in the High Street. Beyond the main street are the former Weller's Brewery buildings in Church Street, now flats, and to the west, seen from the Barn Meadow playing fields are the early maltings built for Weller's in 1829. The Amersham Museum in No 49 High Street gives a visitor access to the interior of a medieval timber-framed hall house and is also a most interesting local history museum.

Chesham, on the other hand, did not have the advantage of a single-minded landowner to protect it and its later 19th-century developments to the

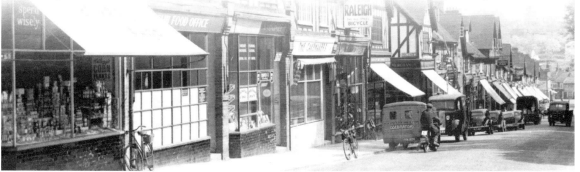

north of the town that clogged the north part of the valley. Further development spread over the hills both east and west, spawned by the arrival of the railway in 1889. Chesham was in any case a more industrially-based town, originally water powered of course. By the 1890s paper-making, straw-plaiting, woodware manufacture including toys, spades and hoops, brewing, shoe-making and other crafts necessitated rows of artisan houses. The town was wasp-waisted at its centre with the High Street pushed hard up against the steep hills to the east of town and the grounds of Lowndes Park and its lake to the west. Where the High Street reached the Market Place the town spread out again, with Church Street leading on to Great Missenden, and Red Lion Street the route to Amersham, heading off south-west and south-east respectively.

Needless to say traffic became a serious issue and the 20th century did its worst, cutting an inner relief road diagonally through the Market Place, severing Church Street from the town by a road constantly roaring with traffic, and continuing north through the east side of Lowndes Park, thus separating much of the town from its park. The High Street became virtually pedestrianised and lost its bustle. The town also suffered some unhappy demolitions, indeed much of Blucher Street, off The Broadway, was demolished for the relief road and car parking. A lamentable Sainsbury's in the northern part of the High Street and an even nastier Waitrose in the Broadway, were just two architectural infelicities. Many other buildings were demolished throughout the 20th century and architecturally Chesham is not a patch on Amersham. However it still has much to commend it and probably the best street architecturally, and the one least damaged, is Church Street. Off this street is the fine medieval parish church and The Bury to its west This is one of two mansions near the church in their own parkland, the other being Bury Hill to its north which was bought in 1802 by Charles Lowndes, owner of The Bury, and later demolished.

The medieval parish church of St Mary, as with Amersham's, was heavily restored in Victorian times but occupies the end of a ridge whose elevation over the town is given further emphasis by the central tower and spire. Inside are some good monuments and in the churchyard is the Lowndes family's stone mausoleum. In the town few buildings stand out in the way they do in Amersham: it is a town of smaller Georgian houses and later insertions and rebuilds, for example the two tall buildings crashing into High Street where the new Station Road was formed after 1890. Church Street and Germain Street come closest in quality to Amersham while up Fuller's Hill, a continuation of Germain Street, there are two distinguished part medieval and Tudor houses with Georgian additions, Germains and Little Germains.

There was also much development, mostly in the 18th and 19th century, along the Chess south east of Chesham along Waterside. Here labourers'

cottages jostle in the narrow valley with small factories, workshops and water mills. The area was provided with its own Anglican church - Christchurch - in the 1860s. Many of the workshops are gone now and many cottages have given way to modernity while one of the oldest watermills, Lords Mill, finally went in the 1980s after years of neglect.

Winding past the villages of Latimer and Chenies, the River Chess reaches Rickmansworth, a town to which the 20th century was somewhat brutal. Ringed on three sides by a northern and western by-pass, it is understandable that many pass by at as much speed as they can muster between roundabouts. The historic town comprised a winding High Street with Church Street its only major side road, retaining more of its older buildings than the High Street. But there are some gems within the town. Disappointingly the medieval church was rebuilt, the tower in 1630, the rest in 1826 and again in 1890. To the west of the church is the town's finest house, The Bury, part 16th and 17th century behind a facade of about 1800 while near the church is The Priory, an early 16th century timber-framed house built as a church house or marriage-feast house. Some old houses, including The Feathers which has a 15th century cross wing and 16th century hall, dot the streets but there has been a lot of rebuilding. To the south the Grand Union Canal passes via Batchworth Lock, a valuable asset to the town, as are the flooded former gravel pits to its west, some now forming the Rickmansworth Aquadrome watersports and leisure facility.

Indeed water plays a significant role in the town's setting and leisure activities. The Grand Union Canal, originally the Grand Junction, reached Rickmansworth by 1796 utilising the valley of the River Colne and, beyond Rickmansworth, that of the River Gade. Paper mills, including that of John Dickinson who bought Croxley Mill in 1828 and leased Batchworth Mill, appeared along the canal as well as industrial expansion of other watermills, such as Loudwater Mill on the Chess, a major paper mill, and the silk mill off the High Street.

As with Chesham and Amersham, the arrival of the Metropolitan Railway in 1887 stimulated a new form of development that these towns had not seen before: the London commuter's semi-detached and detached houses built on estates near the stations transformed the towns through which the railway passed. 'Metroland' estates spread north-west of the town and east of the River Chess Croxley Green expanded north of its railway station. The earlier LNWR branch line from Watford did not have the same effect and indeed the line and the station south of the church have long gone. To the south the eastern part of the grounds of Moor Park mansion became 1930s housing.

Thus we have three very different towns which started out in the Middle Ages as market towns for their localities although, as Kelly's 1895 Directory for Buckinghamshire and Hertfordshire states for

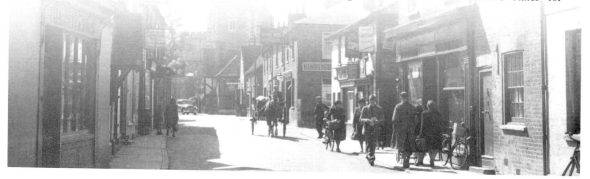

Rickmansworth: 'A market was formerly held on Saturday, but has been discontinued for many years. A cattle fair is still held on November 24th: other fairs have been abolished.' Amersham received its market charter from King John in April 1201, confirming his earlier one of 1200, and granting a weekly market and an annual fair in September. This is now a funfair, but was a livestock and trade fair until the 1940s. Chesham's market charter dates from 1257 and was obtained from King Henry III by Hugh, Earl of Oxford, Lord of the Manor of Chesham Higham. This granted a weekly market and an annual three-day fair.

These three towns set in chalk stream valleys of the Chiltern Hills are each very different in their town plans and in their respective levels of pre-Victorian survival. Amersham is rightly the most visited, the most filled with antique shops and restaurants: the other two are more workaday and more altered.

Chesham retains far more of its historic buildings than does Rickmansworth, but Rickmansworth is worth the effort, perhaps a walk down Church Street, through the Churchyard to The Bury and back along the High Street, or along the canal towpath and Batchworth Lock. I certainly enjoyed walking around the three towns and touring the villages for this book which falls into five chapters. The first focuses on Amersham and Amersham-on-the-Hill while the second is a tour along or near the River Misbourne as it glides through the Chilterns from Little Missenden to Chalfont St Peter. The third chapter is about Chesham which has the most views, many from the late 19th century, and the fourth follows the River Chess from Chesham Bois to Chorleywood via Latimer and Chenies. The fifth chapter reaches the confluence of the River Chess with the Rivers Gade and Colne at Rickmansworth and includes a mini-tour of the town's surrounding villages.

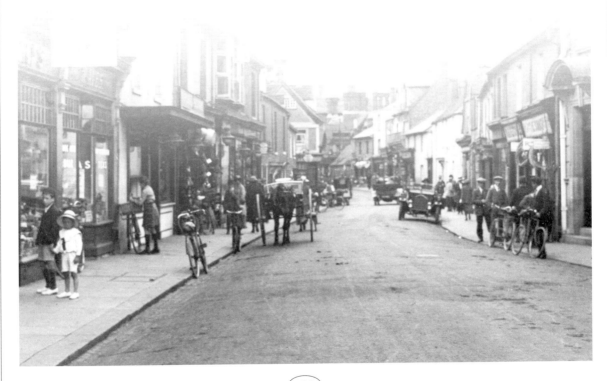

Amersham - Old and New

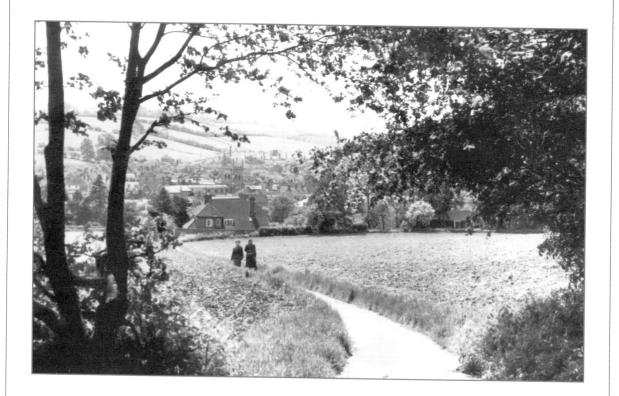

**Amersham
from Parsonage Woods 1958** A148040
Taken from the edge of Parsonage Woods to the north of the
town, this view, almost unchanged today, looks past the
cornfield towards the historic market town nestling in its Chiltern
valley. These fields and the woods were carefully safeguarded
from the post-railway Amersham on the Hill development to
protect the setting of the old town.

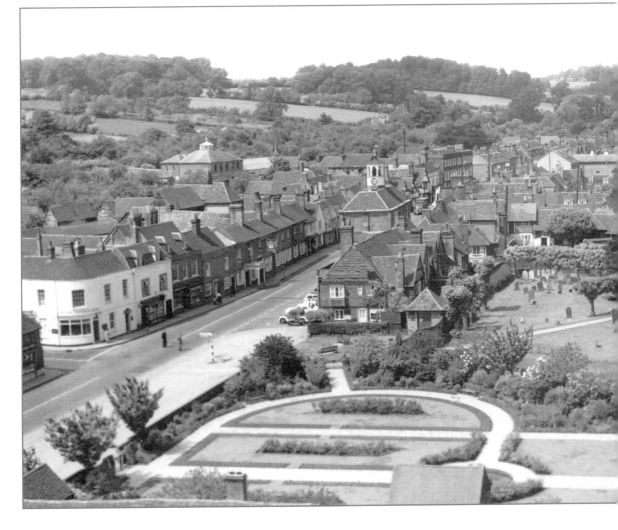

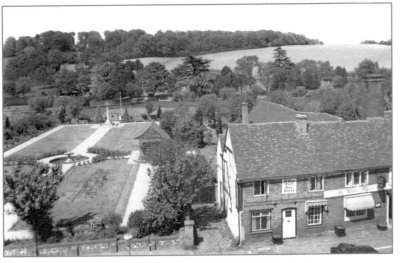

◀ **Amersham
The Garden
of Remembrance c1955**
A148061
Looking north from an upper
window of the Griffin, now an
ASK pizza house, the Memorial
Gardens were created in 1949
to commemorate the dead of
two world wars. A row of
cottages was demolished and
the War Memorial of 1921
relocated here. Behind the
memorial cross a stylish
pyramidal roofed rectory was
built in 1985 to designs of Basil
Spence, the architect of
Coventry Cathedral.

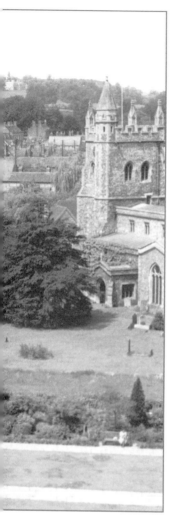

◀ **Amersham**
A General View c1955 A148068
Looking west past the Memorial Gardens, the white building on the far hill, just to the left of the church tower, is Shardeloes, the Georgian mansion of the lords of the manor. Designed in the 1760s by the splendidly-named architect Stiff Leadbetter for William Drake, it replaced a 1630s house and was completed and decorated by Robert Adam. The Georgian stables and service buildings, designed by Francis Smith of Warwick and added to the 17th century mansion for Gerrard Drake in the 1720s, were retained by Leadbetter.

▼ **Amersham, St Mary's Parish Church 1958** A148069
Looking beyond the medieval parish church the building on the hill behind is the Georgian rectory built in the 1730s by the Rev Benjamin Robertshaw, overlooking the town and away from its bustle and smells. Very much the rectory of a prosperous country gentleman and clearly not that of a worker priest! The church has many fine monuments, mostly to the Drake family of Shardeloes, while to its right are the former Weller's Brewery buildings, now apartments.

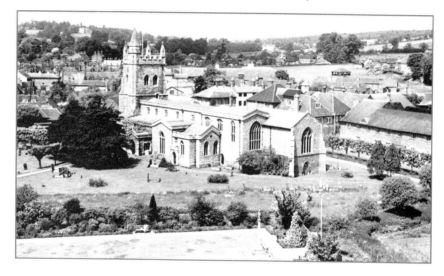

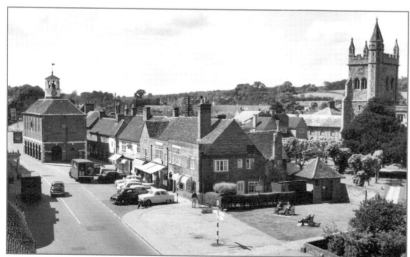

◀ **Amersham, The Church and Market Square c1955** A148059
This view, also taken from an upstairs window of the Griffin, looks into Broadway, much changed in the 1930s and 1940s. Until 1939 the buildings on the right faced Church Alley and the backs of ranges of cottages a few feet away, demolished in that year. Originally medieval and Tudor encroachments onto the old market place, these cottages hid the east view of the 1682 Market House. To the right, further cottages went in 1949 to make way for the Memorial Gardens.

▼ Amersham, Market Hall and High Street c1950 A148018

Now at ground level, Frith's 1950 photographer looks along Market Place past the left turn into Whielden Street towards the Market Hall with the Crown Hotel on the left with its deep porch, now demolished for road improvements. Hidden from this view until 1939 by Church Alley's cottages, the superb Market Hall was built in 1682 by Sir William Drake of Shardeloes. Long a highway bottleneck, it survived 20th century traffic pressures until the town's by-pass was completed in the 1980s.

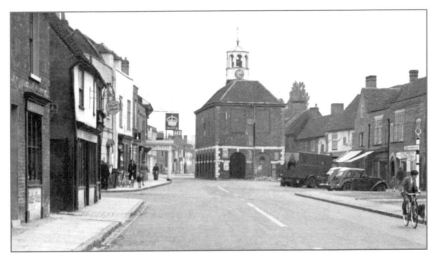

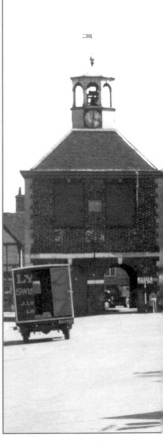

▼ Amersham, St Mary's Church c1955 A148052

This view looks north up Church Street with No 15 on the left, a medieval house with a good crown post roof, and on the right the toy shop with the evocative names of makes of toy on its facade is now a chemist and has had the gable timber-framing rebuilt. The church tower is 15th century, refaced in the 1880s. Beyond is the old Weller's Brewery, later the Goya perfume factory and since the 1980s converted to stylish apartments.

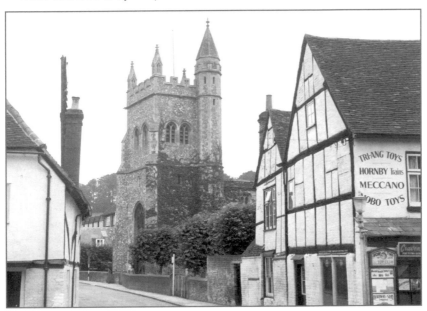

▲ Amersham, High Street c1950 A148012

The photographer has now moved west down the High Street, a superb long and wide street lined by timber-framed and brick houses - one of the best historic townscapes in Buckinghamshire. In this view are two of the town's oldest coaching inns, the timber-framed King's Arms in the foreground and the Crown Hotel in the distance with its now demolished porch and hanging sign, opposite the Market Hall. Here an 18th century brick facade hides a 16th century interior.

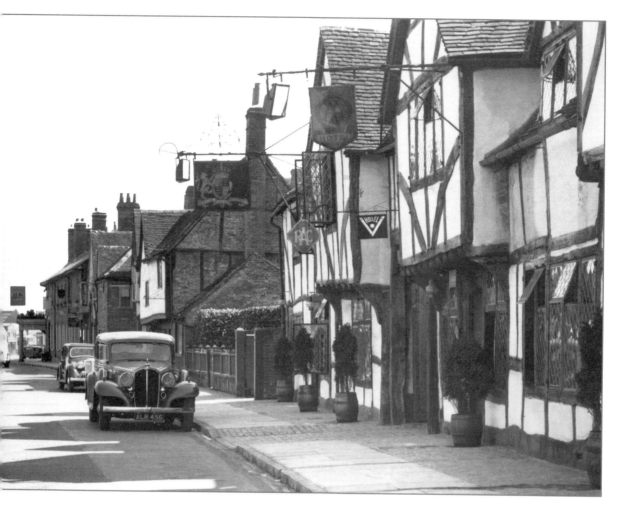

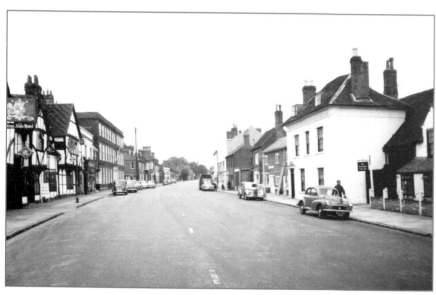

◀ **Amersham, High Street 1958** A148064
Beyond the King's Arms is the austere three-storey Elmodesham House with its straight parapet. Built around 1720 for Charles Eeles, a timber merchant, it was wittily named Woodville House until 1907 when it was enlarged by six identical bays to the right and the doorcase moved to the centre. From the 1930s until the 1980s it was council offices but is now apartments and contains some fine 18th century panelling and ceilings painted with mythological and hunting scenes.

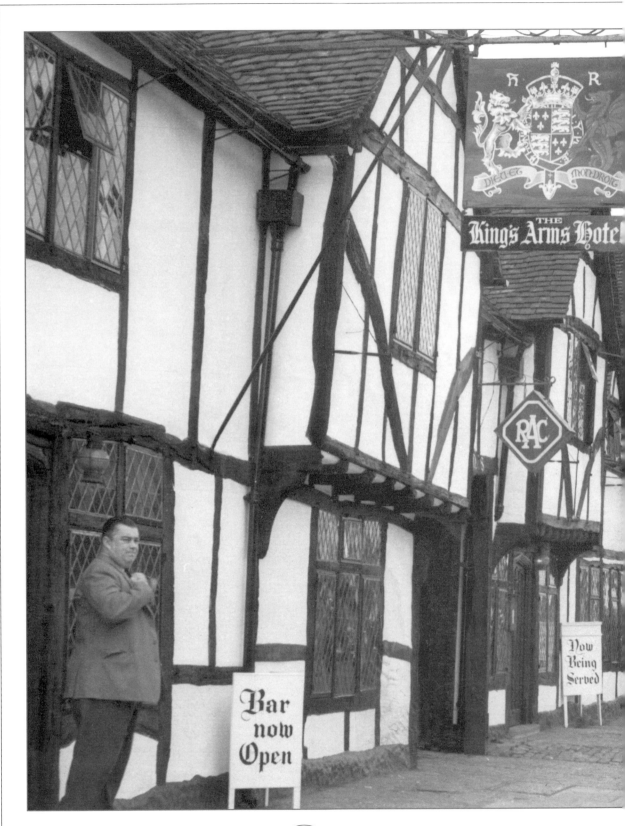

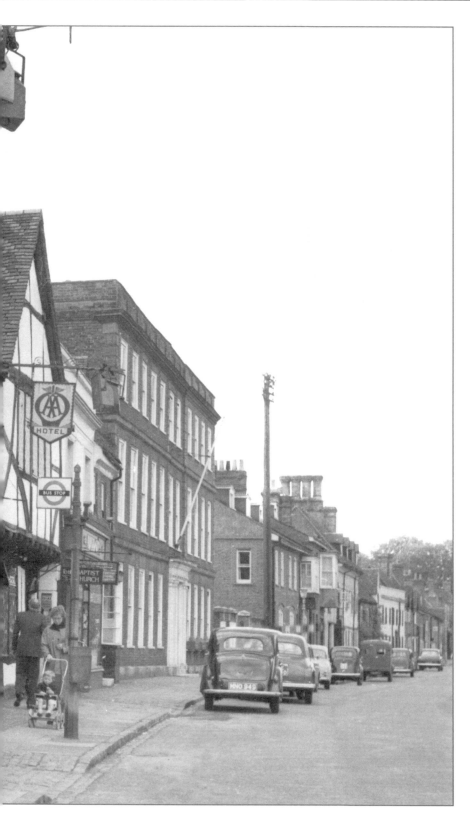

Amersham, The King's Arms Hotel c1955

A148072

The King's Arms is not all it seems: all the timber-framing to the left of the RAC sign is modern, dating from 1936 when a plain Georgian block, itself tricked out with fake timber-framing, was drastically remodelled in Tudor style using old timbers, adding leaded casement windows and a jettied upper storey. Beyond is a genuine 16th century hall house with jettied cross wings.

▼ **Amersham, High Street c1955** A148045

From further west this view gives a good idea of the Georgian and later brick frontages added to the mainly 17th century timber-framed cottages lining the High Street and giving the town its distinctive character. The lime trees on the right are in front of the Sir William Drake Almshouses built in 1657, an open courtyard with a brick wall and archway to the street and ranges of cottages for 'the relief of six poor widows well reputed in the parish'.

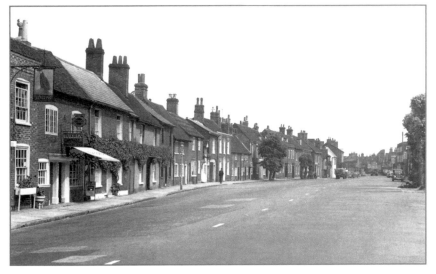

▼ **Amersham, The King's Arms c1955** A148037

Back towards the Market Hall we have another view of the King's Arms, the left hand part and the chimneys dating from the 1936 remodelling. To the right is the fine late Victorian shopfront to Haddon's the chemists, now Liz Quilter and without the cresting. The alley through the archway to its left leads to the Baptist Chapel built behind the High Street in the late 18th century, its roof seen on the left of view A148068.

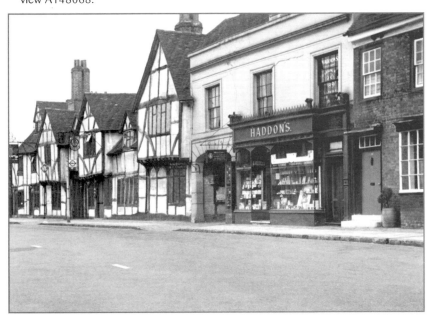

▲ **Amersham Sycamore Road c1950**

A148027

The new town of Amersham-on-the-Hill developed from the 1890s when, after 60 years of opposition, the Drakes and then the Tyrwhitt-Drakes finally allowed the railway to come to Amersham, but up the hill and out of sight of their mansion and park at Shardeloes. The Metropolitan Railway's station opened in September 1892. This view captures well the somewhat disparate architecture of the shopping centre with mock timber-framing vying with mock Georgian styles.

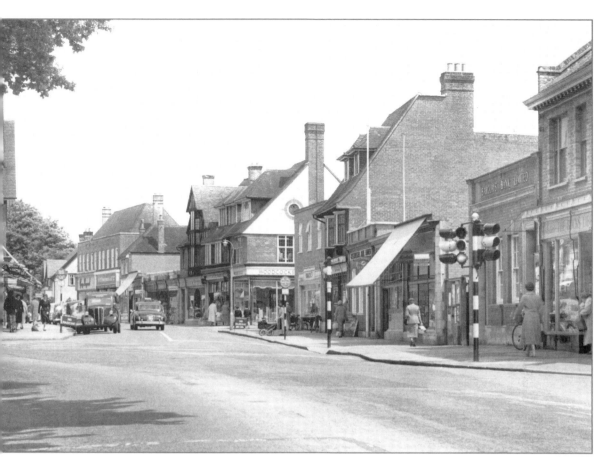

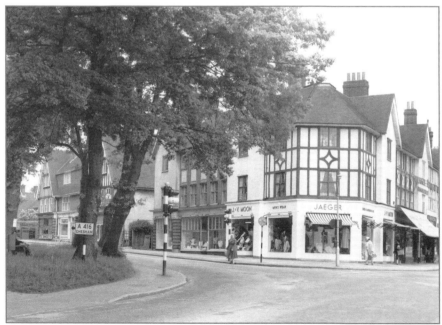

◄ **Amersham Chesham Road c1955**

A148031

Oakfield Corner, built around 1910 and part of the earlier phase of Amersham-on-the-Hill's expansion, chose the vernacular and timber-framed tradition for its shops with flats above. The photographer is in Rectory Hill, until the 1890s the only route up the hill from the old town. The oak trees at the junction with Chesham Road have survived while Rectory Hill becomes Sycamore Road to the right of the junction.

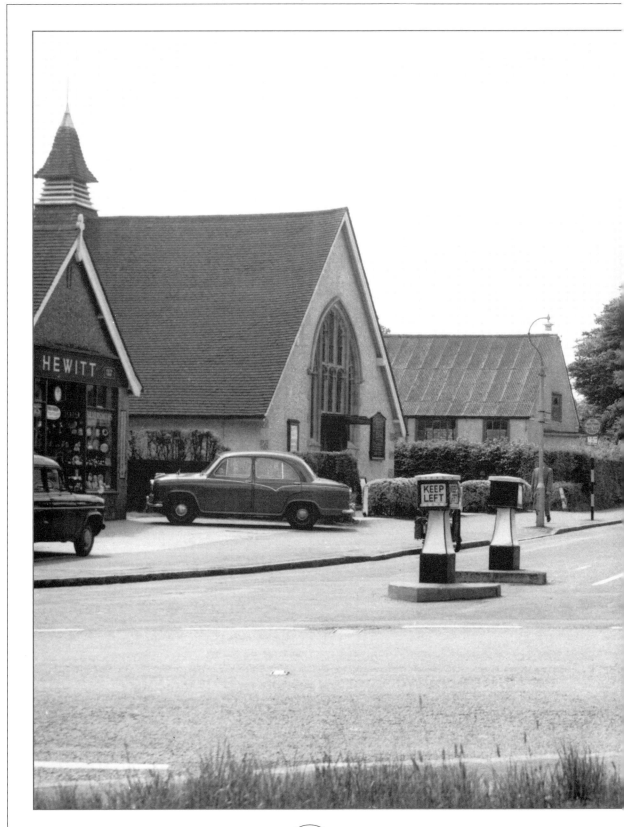

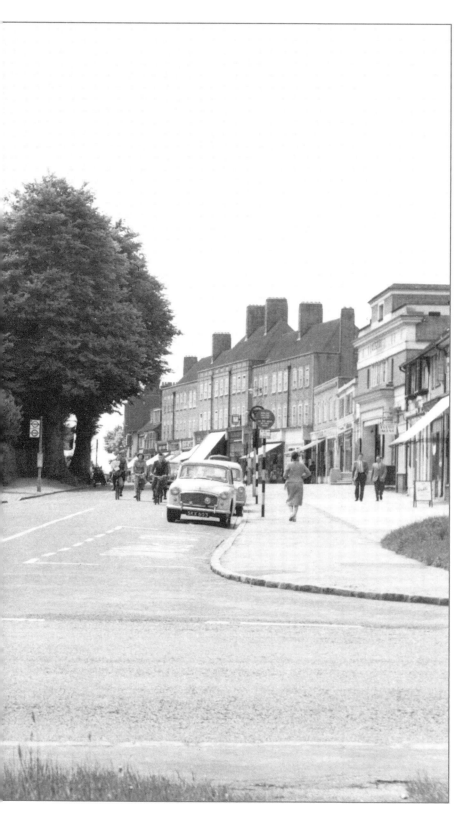

**Amersham-on-the-Hill
c1955** A148036
This view is at the
junction of Woodside
and Rickmansworth
Roads and looks south-
west towards Oakfield
Corner. Hewitts, the Free
Church of 1913 and the
hall beyond were
demolished in 1963 and
replaced by the tawdry
flat-roofed three-storey
Sycamore House flats,
offices and shops. The
large many-chimneyed
neo-Georgian buildings
on the right, Chiltern
Parade, were built in
1936 by Sainsbury's who
occupied the centre
shop. Nearer the camera
is the Regent Cinema of
1928, closed in 1962
and tragically demolished
and replaced by a frozen
food shop.

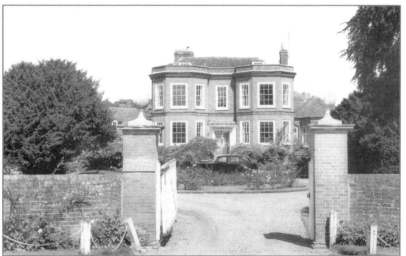

◄ Little Missenden
Missenden House c1955
L350005
The partly Tudor Manor House is at the crossroads in the centre of the village, but at the east end is an equally fine house, Missenden House. Dated 1729 on a rainwater head, its front with its flanking full-height bay windows is more window than wall. A most elegant composition with an equally elegant limousine parked outside.

A Tour Along the Misbourne Valley and the Chiltern Hills to the South

◄ **Little Missenden, The River c1955** L350008
Our second tour starts three miles west of
Amersham in the delightful village of Little
Missenden which grew up along the south bank of
the River Misbourne and separated from Amersham
by the parkland of Shardeloes. Here we look east
from the bridge over the Misbourne along the backs
of Manor Farmyard, now houses, the Red Lion pub
and cottages beyond, a view now somewhat
obscured by stables to one of the converted barns.

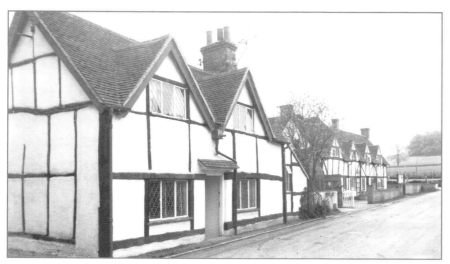

◄ **Little Missenden White
Cottages c1955** L350015
On the lane south from
the crossroads the last
two houses on the left are
timber-framed, the White
Cottage on the left with
original framing in the
side elevation and fake to
the front. Since 1955 a
further bay has been
added partly screening
Town Farm Cottage
beyond, whose two far
bays are modern fakes
also. In the distance is
Breaches Wood, a typical
Chiltern beech hanger.

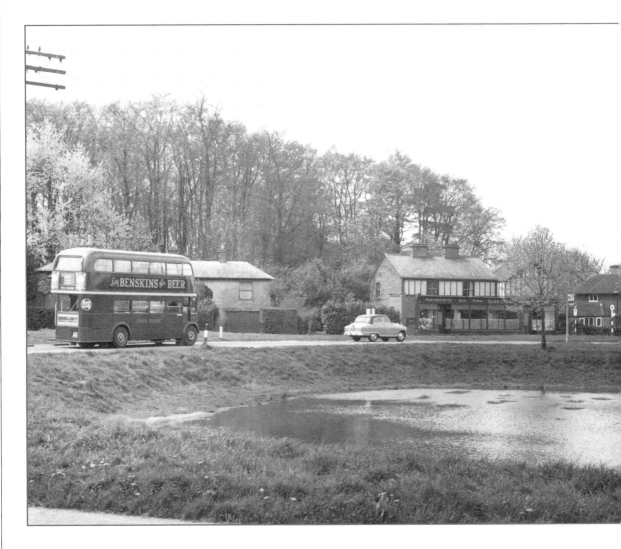

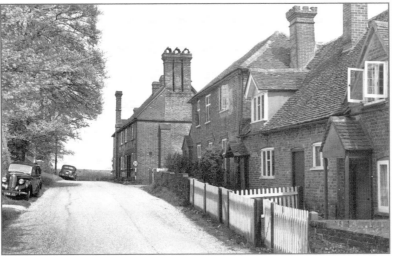

◀ **Penn, Old Cottages c1955**
P283001

Tylers Green merges to the east with the older village of Penn, mainly along Church Road. Here Frith's photographer looks up Pauls Hill towards the Church Road junction with Holy Trinity's churchyard behind the trees on the left. Nos 1, 2 and 3 Church Cottages on the right were once a single 17th century timber-framed house whose original brick stack with three chimney shafts can be seen on the gable. The front is 18th century brick dating from its sub-division into three cottages.

Penn, The Green c1955
P283005

Our route now moves out of the Misbourne Valley onto the chalk plateau. Tylers Green was the centre of a major medieval tile-making industry whose decorated floor tiles were used at Windsor Castle in the 14th century and for paving numerous Chiltern churches. The village surrounds a large green and common and this view looks across the pond towards the bellcote of the 1870s primary school.

▼ Coleshill, The Church c1955 C496008

Moving east we reach Coleshill, a mile south of Amersham. This village was an enclave of Hertfordshire, being transferred to Buckinghamshire in 1832, and there are many good 16th and 17th century timber-framed farmhouses and cottages within the parish. It had a chapel of ease that was demolished around 1800. The present church of 1860, by G E Street, the architect of London's Law Courts, is a simple flint church with brick bands and stone dressings. Its churchyard acquired a Millennium lych gate in 2000.

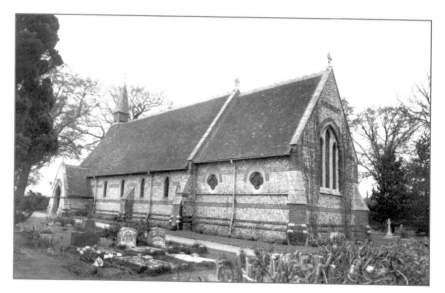

◄ Seer Green, Chalfont Road c1960 S568009

South-east of Coleshill, Seer Green was a small village that became a separate parish in 1847. Nowadays the old core is surrounded by 20th century housing, some small and the rest 'Metroland' detached houses in spacious well-treed gardens, between it and Seer Green and Jordans railway station on the Marylebone line. In this view the bellcote of the church, built in 1846 by James Deason in preparation for parish status and costing £1,700, can be seen behind the cottages.

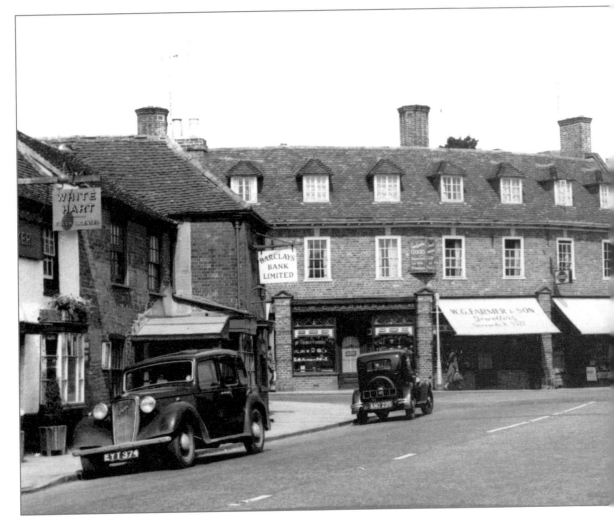

◄ **Chalfont St Peter Market Place c1950** C524008
Up the hill towards one of Chalfont St Peter's commons, Gold Hill, Tudor-style shops and flats were built on the north side of the road in 1922, called Market Place and decked out with fake timber-framing and gables. Note echoes of wartime in 'The Bombed Shop'. The cottages at the far end went in slum clearance and were replaced in 1966 by an insensitive shopping precinct with flats over. St Peter's Court is another contribution to the loss of the historic character of the village.

Chalfont St Peter, High Street c1950
C524007

The old centre of Chalfont St Peter has suffered greatly, by-passed too closely and swamped by housing estates, the houses steadily increasing in size before merging with the affluent 'Metroland' of Gerrards Cross. The White Hart on the left survives, as, of course, does St Peter's church beyond the neo-Georgian shopping parade. A Georgian tower and church of the 1710s, heavily remodelled in the 1850s and recast in Gothic style in polychrome brick by G E Street: he had described the Georgian church as 'a very ugly brick church'.

Chalfont Common
The Post Office c1965 C692034

East of the Misbourne, beyond Gravel Hill, Chalfont Common was one of Chalfont St Peter's three commons. To the north, the National Society for Epileptics, informally grouped round Arts and Crafts style houses and cottages, started in 1895 and still going strong. Housing of all sorts grew up on the rest of the Common and in this view Fernlea House, on the left, is from the 1890s while the pair of shops is from the 1960s, the stores now a Spar and the other shop a hair stylist.

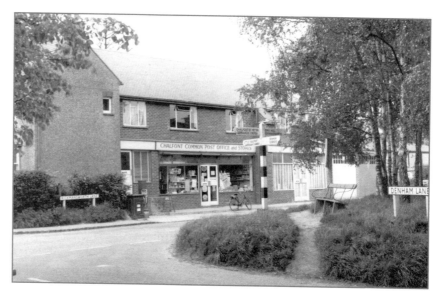

Chalfont St Giles, The Pond c1955 C498022

Chalfont St Giles retains much more of its heritage and character than its southern neighbour, Chalfont St Peter, with a High Street lined with good buildings, a pond and the parish church tower peering above the tiled roofs. The 17th century brick cottages in front of the tower in this view were built as charity cottages. The church itself has a Norman south aisle and sits in a delightful churchyard with the backs of timber-framed cottages on one side and the Misbourne in its valley on the other.

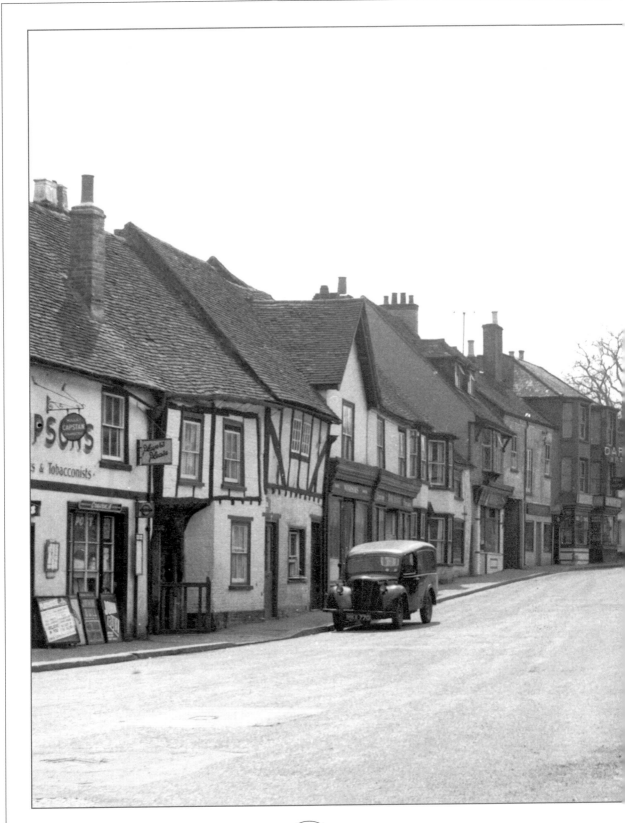

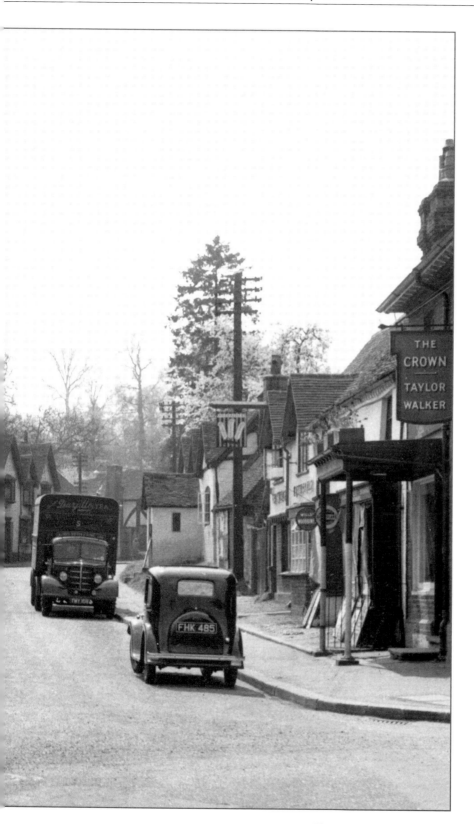

**Chalfont St Giles
The Village c1950**
C498015
Looking west uphill along the High Street, the jettied timber-framed cottages span an alley to the church and its lychgate. On the right the hard red brick pub, The Crown, is dated 1890 while beyond is The Feathers, a good 17th century house, refronted in the 19th century. The timber braces in the distance, just to the right of the lorry, belong to Stonewells, a late 15th century hall house with crosswings.

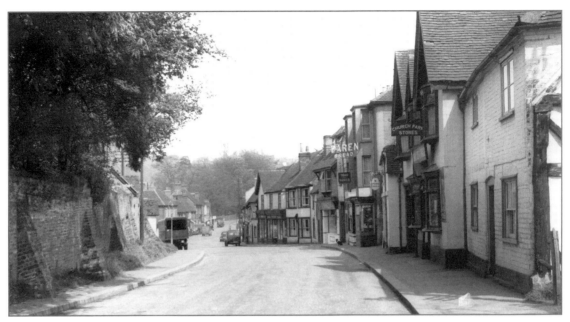

Chalfont St Giles, The Village c1955 C498014
Looking east back downhill from the junction with Bowstridge Lane, the gable on the right is the remnant of a cottage demolished to improve visibility from the lane. The shop with the Daren Bread sign is still a bakers, Stratton Bakery, and A Warner beyond is still a butchers. The buttressed wall on the left belongs to the former rectory, a good brick house of about 1700 with seven bays of sash windows.

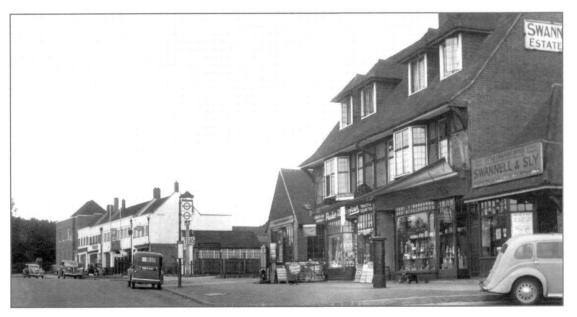

Little Chalfont, The Village c1955 L505311
Little Chalfont, a name given the area by developers in the 1920s, grew up around Chalfont Road Station on the Metropolitan Line which opened in 1889, with a branch to Chesham opening the following year. The station was built amid farmland and spawned much development. This view of the somewhat architecturally amorphous centre has the station, renamed Chalfont and Latimer in 1915, out of view to the right. Swannells is still an estate agents, Bairstow Eves, and the neo-Georgian building on the left is the 1935 telephone exchange.

Chesham

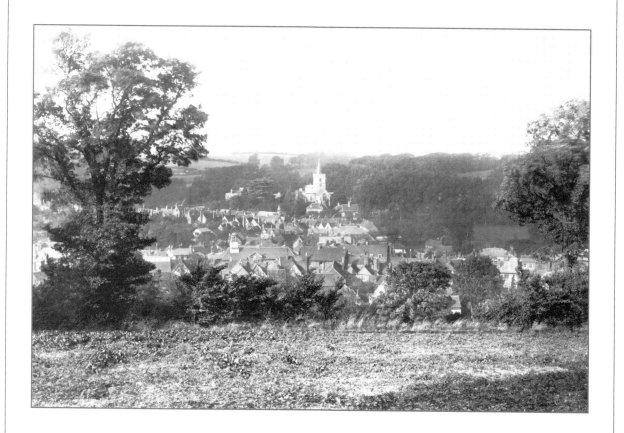

Chesham
General View 1897 40531
Looking west from the chalk hills east of the town, undeveloped
to this day, Chesham nestles in the deep-cut valley of the River
Chess. Nearer the camera is the bell turret of the old Market
Hall and beyond on the other side of the valley is the tower and
spire of the parish church and to its left, beyond the cedar tree,
is The Bury, Chesham's grandest house. Dating from 1712 and
set in a landscaped park it was built for the then Secretary
to the Treasury, William Lowndes.

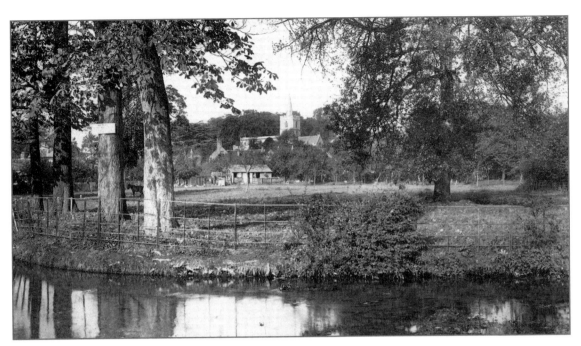

Chesham, The Church 1897 40540
Now in the valley, this view looks north-west across the water meadows towards the church from beside the stream where it passes under Germain Street. The meadow is now the Water Meadow Car Park and from this vantage point the church is screened from view by high laurel hedges and only the spire can be seen.

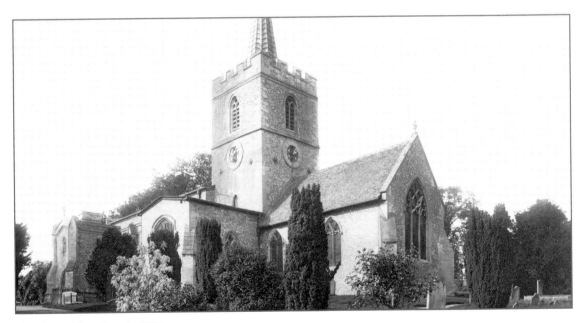

Chesham, The Church 1897 40541
St Mary's Church is on rising ground west of the town, with Lowndes Park to its north and east and The Bury to its west. The large cruciform church dates back to the 13th and 14th centuries. The tower bell chamber and south porch were added in the 15th century and the leaded spire in the 18th. The church was heavily restored by Sir George Gilbert Scott in the 1860s. By the south transept is a celtic cross memorial to Thomas Harding of Dunsmore, a protestant martyr burnt in 1532.

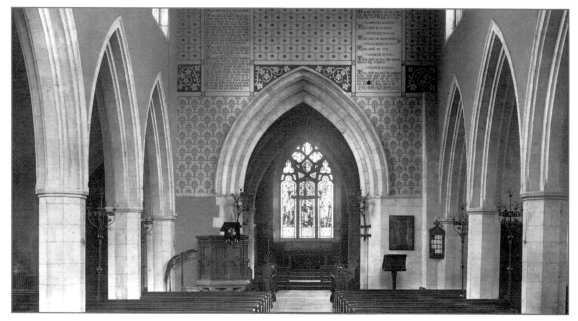

Chesham, St Mary's Church, The Interior 1897 40542

This interior view looks east along the nave with its 13th century arcade and into the chancel to George Gilbert Scott's more 'correct' Decorated Gothic style window. The stencil work and texts above and around the chancel arch, including the Ten Commandments, are now hidden by modern paintings of 1970 by John Ward showing scenes from Holy Week and creating a more cheery atmosphere than the dour stencil work.

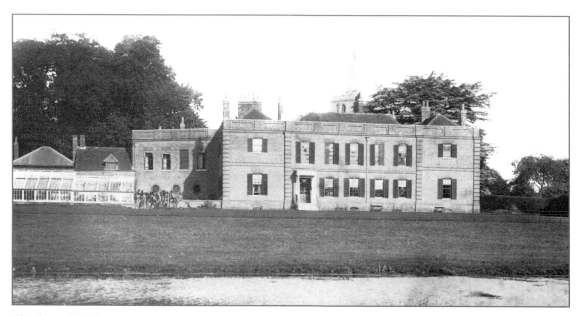

Chesham, The Bury 1897 40544

Immediately south of the church whose spire can be seen behind, is The Bury. It was built in 1712 for William Lowndes, Secretary to the Treasury, who came from Winslow in central Buckinghamshire where in 1700 he had built Winslow Hall. The south front faces a lake made by damming a chalk stream. Lowndes' house is the central five bays only; the outer bays were added around 1800 as were the service ranges. The house and outbuildings are now offices.

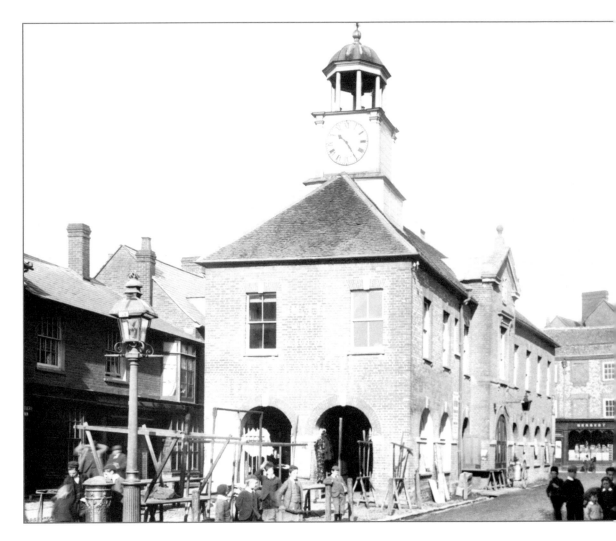

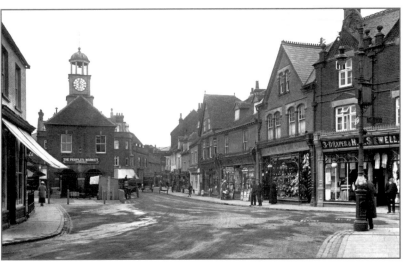

◀ **Chesham, Market Square 1921** 70536

The Market House with its clock and bell turret was built in the 18th century but extended and largely reconstructed by Lord Chesham in 1856. It had an open ground floor and town hall above it and, although not as architecturally interesting as nearby Amersham's 17th century market hall, was a key feature in the town. The fine late 19th century shopfronts to the right have mostly gone but Smith Brothers is still a stationers, JPS.

Chesham, Town Hall 1897 40535

Chesham has been a market town since 1257 when Hugh, Earl of Oxford, obtained from King Henry III a grant of a weekly market and annual three-day fair. It is likely that the town was then laid out along the east side of the stream, with its market place and burgage plots High Street, the older settlement being along Church Street.

Chesham, Market Place c1965
C81088

A tragedy for Chesham was the demolition in 1965 of the Market House or Town Hall in the alleged interests of those great behemoths, the motor car and lorry. Ironically, when finally built in the 1980s the relief road, St Mary's Way, demolished the south part of market-place, and the town hall need not have been demolished. Certainly the market-place is a weaker affair now, and only partly compensated by a clock tower erected here in 1992 with similar detail to the old town hall's cupola.

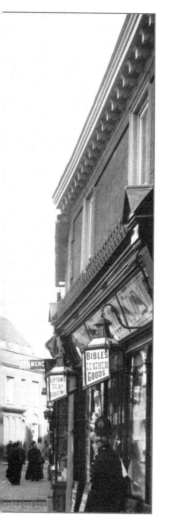

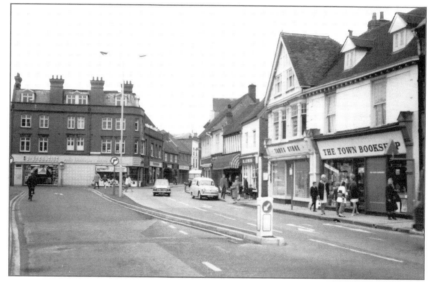

Chesham, High Street 1897 40537

This view, looking north along the High Street which gently and picturesquely winds along rather than following a straight line, shows the George and Dragon inn on the left with its projecting sign reading 'Commercial Hotel' and to its left a bitter rival, the Dunlop Temperance Hotel. Note the shop awnings all along the sunny west side of the street and the ornate Victorian gas lamps.

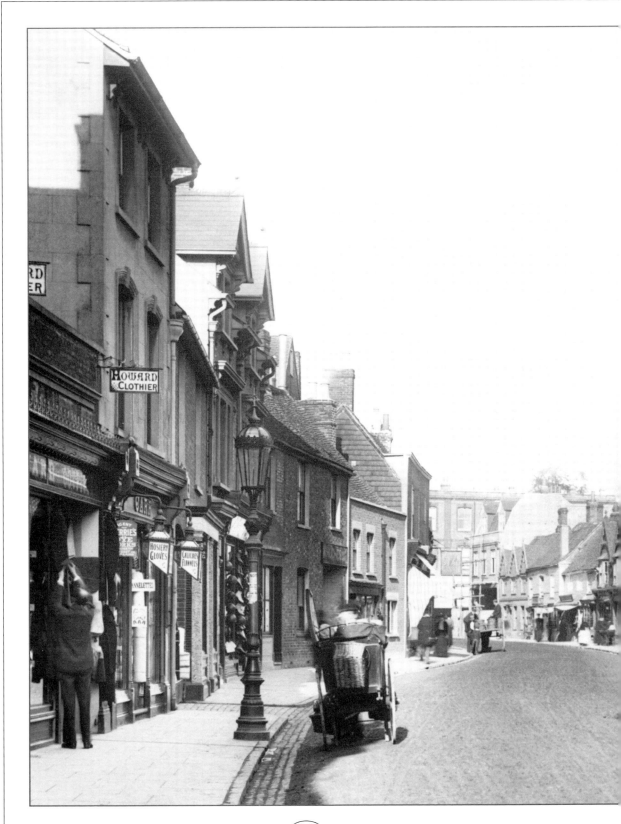

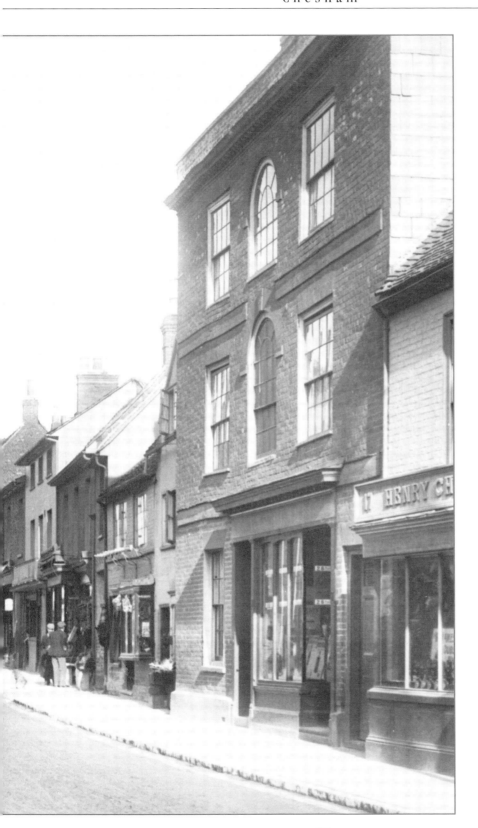

**Chesham
High Street 1897**

40538

A little further north, this view records the High Street before extensive rebuilding took place. The tall building on the right was refronted about 1920 and Henry Chilton was replaced by the 1930s Midland Bank, stone faced and Moderne, now the HSBC bank. Howard's fine shop front on the left, long demolished, is now Baines Walk, leading to the 1990s Chesham Town Hall, named in honour of Arnold Baines, a councillor but also an eclectic local historian noted for his work on Anglo-Saxon land charters.

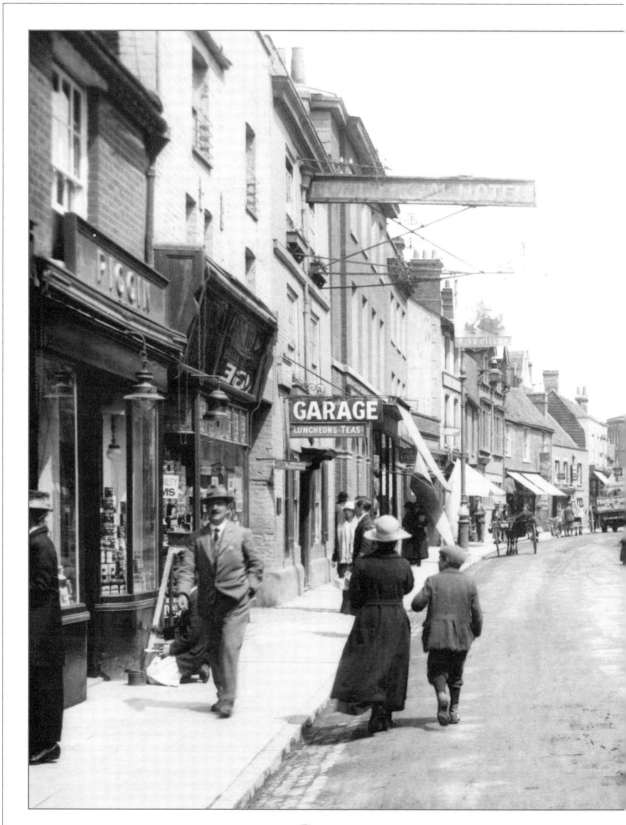

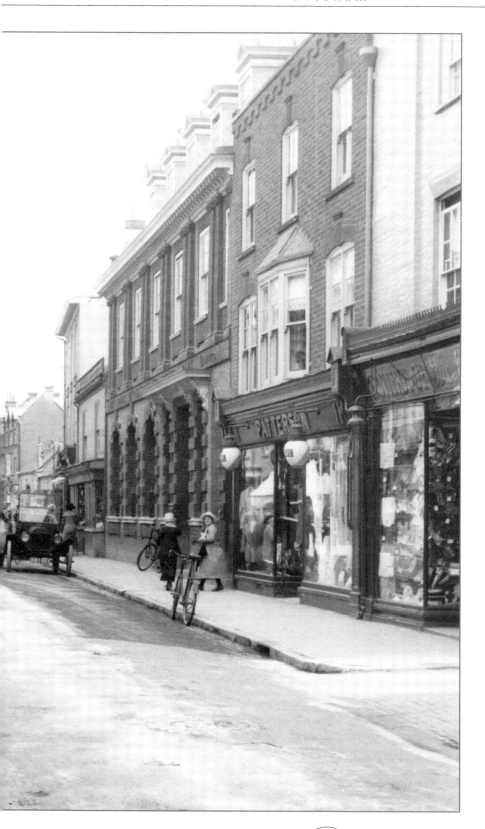

**Chesham
High Street 1921**
70538
The most striking change between this view and the 1903 view on the next page is the splendidly ornate bank building which replaced the two buildings beyond Patterson's. Dating from about 1912 and now the NatWest Bank, it is in Queen Anne style using grey brick with fiery red brick dressings, deep modillioned eaves and large pedimented dormers. The Dunlop Temperance Hotel seems not to have survived World War I and the Fry's cocoa shop on the far right is now Gutteridge's, 'The Modern Tailor'.

▼ **Chesham, High Street 1903** 49238
By 1903 the George and Dragon (of the Commercial Hotel sign) looks directly across the road at its rival, the now relocated Dunlop Temperance Hotel (above the Fry's Pure Cocoa signed shop window). Their old premises on the left has become Piggins, next to the ironmongers, H Wallace. Note the building beyond Patterson's on the right and compare it with view 70538

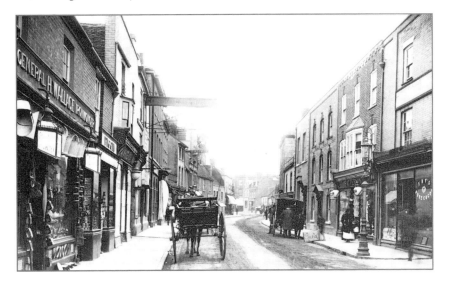

▼ **Chesham, High Street 1921** 70537
This view looks south down the High Street past a motor bike with its acetylene headlamp towards the old Market House with its cupola. More change and continuity: the three-storey building with the four lamps is still a shoe shop, Stead and Simpson rather than Freeman Hardy and Willis, but the cycle shop on the left, festooned with tyres, is now a jewellers. The building beyond, between it and the Queen Anne style bank, was demolished about 1930 and replaced by a smart Moderne stone-fronted Midland Bank.

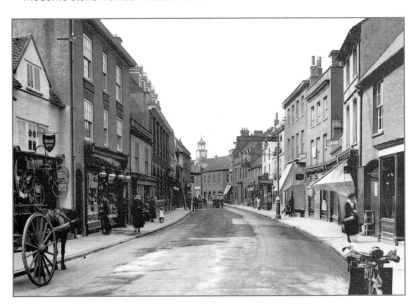

▲ **Chesham, High Street c1955** C81033
Moving further north and into the 1950s, Frith's photographer looks south down the High Street from the Broadway. All has gone on the right as far as and including the high five-pot chimney stack, but on the left the high three-storey building of the 1890s, once the Chess Vale Temperance Hotel, remains as shops and 'Stage 2' nightclub, while the 1898 bank beyond with the pinnacled gable is now 'Chandler and Friends' bar. Beyond, much is rebuilt, apart from the 18th century three-storey building with a pediment and Venetian windows.

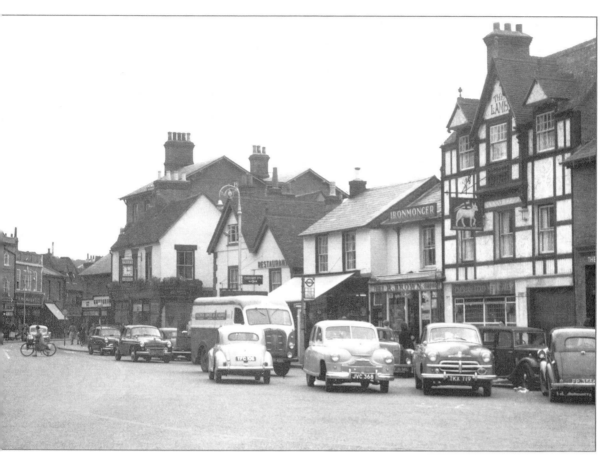

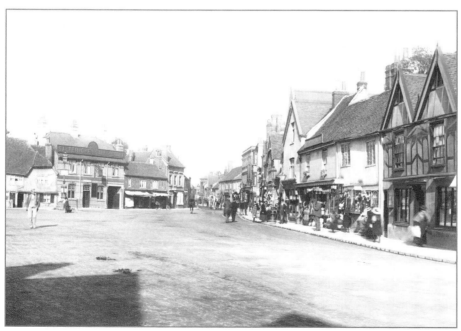

◄ Chesham
The Broadway 1897
40533
The High Street widens out into the Broadway with Blucher Street merging from the left and the High Street continues north as far as the foot of White Hill. The Broadway was formerly known as Pillory Green for obvious reasons but this name gradually fell out of use. This late Victorian view shows one of the old cottages surviving next to the newly rebuilt Cock pub selling Salter's Fine Ales and Stout.

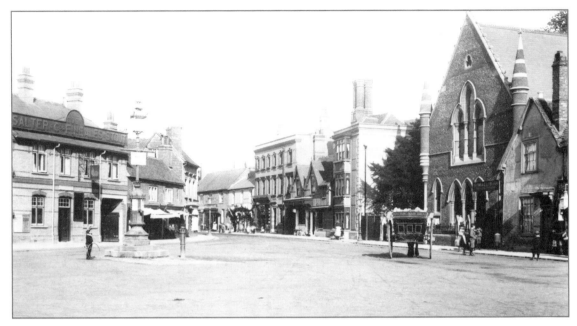

Chesham, The Broadway 1897 40534

Looking north into the continuation of the High Street, the Cock pub on the left survives while on the right is the 1886 Congregational Chapel, an Early English Gothic style front flanked by pinnacled turrets, which replaced one of 1724 which had been clumsily enlarged in the 1820s. Beyond, the building with the four-shaft 17th century chimney stack was used as the Post Office until recently and is now a clothing shop.

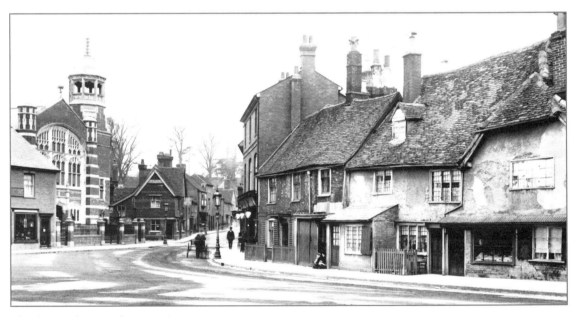

Chesham, The Broadway 1903 49240

Looking towards Blucher Street the old and admittedly somewhat run down cottages survived until Brandon's store replaced them in the 1930s, a three-storey white painted block at odds with everything else around. The tall three-storey building remains, now an Oxfam shop, while all beyond the towering Baptist Church on the left has since been demolished and is now the entrance to the car parks formed between the backs of the High Street houses and the 1980s relief road, St Mary's Way.

Chesham, The Baptist Church 1903 49241
In contrast to the Early English Gothic of the Congregational Church of 1886, now the United Reformed Church, on the east side of the Broadway, the Baptists chose Perpendicular Gothic for their 1901 church. The architect was J Wallis Chapman who used brick with stone bands and dressings topped off by an open cupola. The walls and gates and the finials have gone.

▼ **Chesham, The Broadway 1906** 53647

Little survives to the left of The Carlton Printing Works, nowadays Threshers wine merchants, and the shop-blinded two-storey building at the far left. The Lamb pub, a late Victorian insertion, was demolished in 1974 and replaced by the present Boots, while all to the left of it went for the pallid neo-Georgian Martin's and a brutalist Waitrose supermarket with concrete panels and a crass projecting bay, all utterly out of keeping. This is now a MacDonalds restaurant.

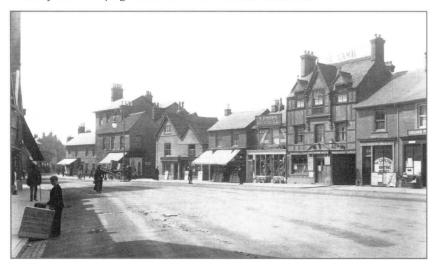

▼ **Chesham, Broadway 1921** 70540

Much more survives of the buildings on the left side of the Broadway, seen here just before the War Memorial replaced the drinking trough and lamp post. The tall buildings behind the lamp post, one with a sign for the Club and Literary Institute and built as a temperance hotel the other a bank dated 1898, flanked the entrance to Station Road. This road was cut into High Street to give access to Chesham's terminus station on the Metropolitan Railway branch opened in 1889.

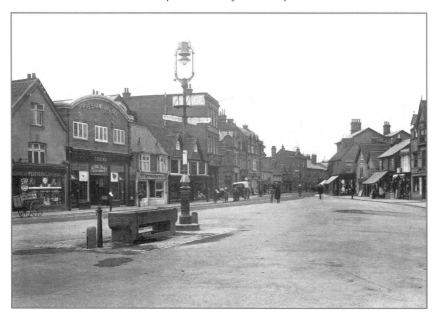

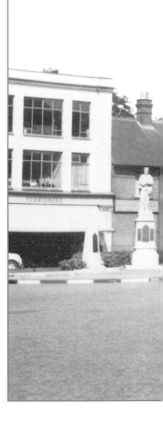

▲ **Chesham, High Street and War Memorial c1955** C81022

The Astoria cinema, originally named the Chesham Palace cinema and replacing Harding's ironmonger's shop, went in the 1970s and the site is now occupied by an architecturally undistinguished Superdrug. On the left is the white render of the former Brandon's department store, a somewhat overpowering building, and to the right of The Cock Tavern is the 1950s neo-Georgian Barclays Bank, itself replaced in the 1980s.

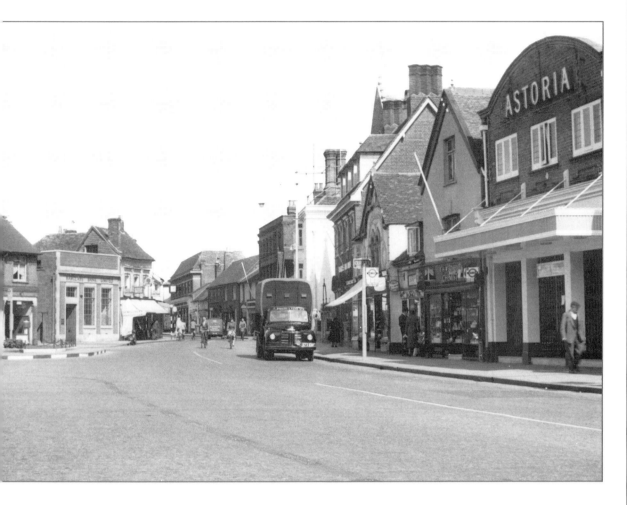

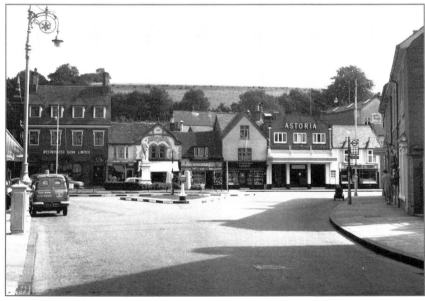

◀ **Chesham, The Broadway c1955** C81024
Looking east from Blucher Street this view shows how steeply the chalk hills rise behind the town, still undeveloped. The Westminster Bank on the left, a competent neo-Georgian building, is now Nationwide. To its right is Cameo House, a colourful and ornate late Victorian refronting, dated 1890, of an earlier house. Weatherill's, the gabled building next to the Astoria, is still a chemist, Garlicks.

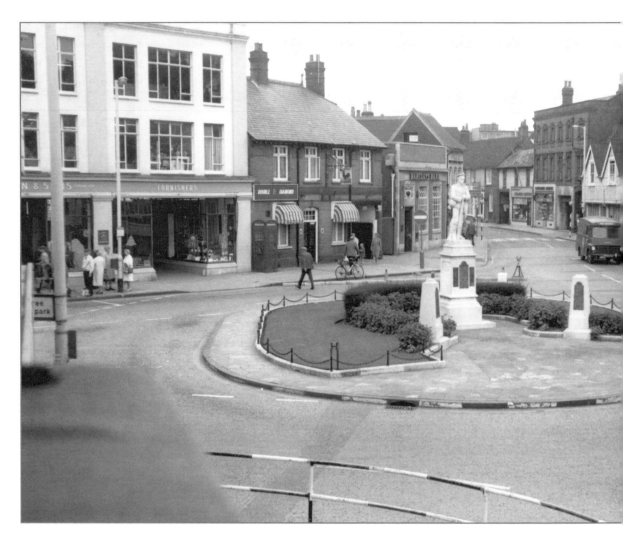

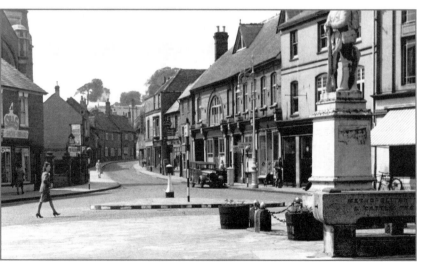

◀ **Chesham, Blucher Street c1950** C81002
Brandon's on the right is now Brandon House, and Broadway Court beyond lost its shopfronts in the 1980s. The tall building beyond and all those on the left beyond the Baptist Church were demolished for car parks, inner relief roads, and a roundabout: Blucher Street is very much truncated nowadays. Sills shoe repairers on the left is now a chiropodist – continuity of a sort.

Chesham, Town Square c1965
C81089

Chesham's War Memorial, a statue in very white Portland Stone of a soldier with his rifle, was unveiled in 1921 and sits in a small green, now much altered. A temporary memorial was set up near the Market House before this one was built. The Post Office building on the right with the big 17th century brick stack is now a pub wittily called 'The Last Post'. Brandon's department store with its classical pilasters concealing its steel frame is now shops and offices.

▼ Chesham, Missenden Road 1921
70550

Leaving the town centre we move along Church Street to the Missenden Road, just past the junction with Pednor Road and Wey Lane. The railings in the foreground guard the chalk stream as it heads east into the town to become the River Chess, while the cottages beyond had just been rebuilt, replacing ramshackle older ones. On the left, only the far left - No 6 - survives, now rendered; the timber-framed ones beyond went in the 1950s, partly for road improvement.

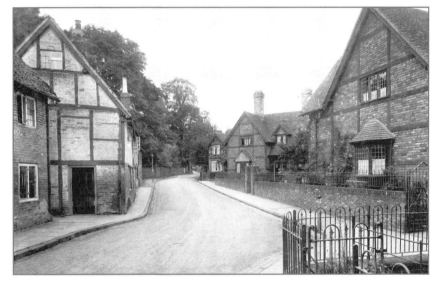

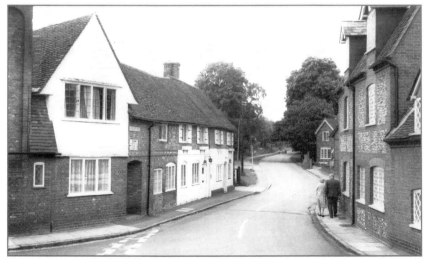

◄ Chesham, Church Street c1965 C81082

40 years later and further back on the Wey Lane junction, we see the far cottage, No 23, on the right, has been largely rebuilt. The white gable and stack is 1930s infill and the last cottage in the left hand row features in view 70550. The demolished ones in that view were replaced by Dawes Close, a group of single storey cottages, built in 1959 for the Mary Gertrude Davies Trust, set around a small green whose access can be seen by the lamp post.

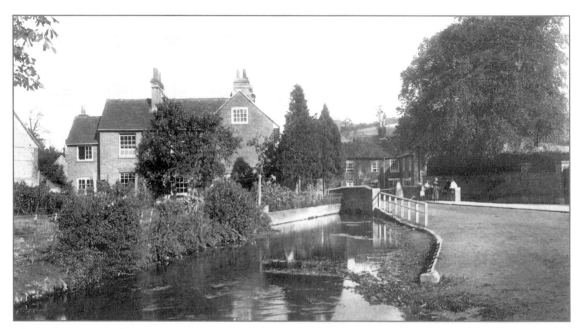

Chesham, Town Bridge 1897 40539

For this view Frith's photographer swung his camera north-east from view 40540 (page 38) of the church looking across the water meadow. Here the stream widens and was used as a waggon wash. He is looking along Germain Street towards the town centre and Market Place, but the houses beyond the bridge have long been demolished. The tree and garden walls belong to the Meades, a house of about 1800 with a fine Ionic porch and set in large grounds.

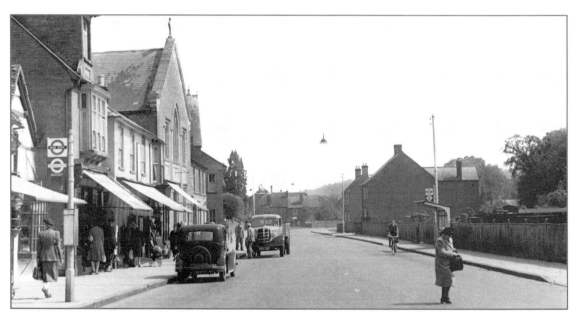

Chesham, Red Lion Street c1950 C81001

The original Red Lion, after which the street was named, stood at the junction with Germain Street and, due to road improvements, was replaced by a 1930s neo-Georgian road house style pub. Here the photographer looks south-east from the East Street junction past Hyatts Yard and, past the gable of Zion Hall, to White Lion Yard with the roof of the Trinity Baptist Church beyond, whose foundation stone was laid in 1897. Note the street lamp suspended on a wire across the sreet.

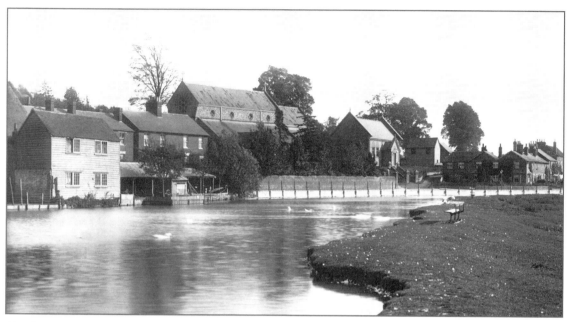

Chesham, Waterside 1897 40547
South-east of Chesham town centre the road runs alongside the River Chess in its flat-bottomed valley. The road is lined by mainly 19th century cottages in which lived the workers from the watermills, workshops and small factories that were originally powered by their water wheels, later by steam engines. This view looks across the river from the meadows towards Christchurch with the now demolished church hall to its right.

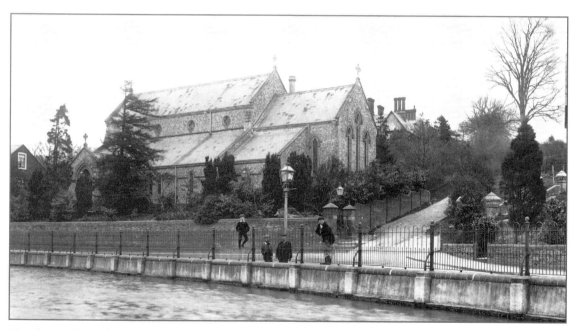

Chesham, Christchurch 1903 49242
Taken from the footbridge over the river, the towerless Christchurch was designed by Raphael Brandon and dates from the 1860s. Built to serve the 'new' industrial settlement along the river, the flint church is in an austere Early English Gothic style. Behind are the chimneys of its vicarage, now demolished for modern terrace houses, while on the right is the church hall gable, also demolished for the modern close of houses, Trapp Court.

▼ **Chesham, Waterside 1921** 70542

In this view the photographer is looking upstream towards Chesham. The house with the two- bay windows replaced the weatherboarded one in view 40547 around 1900. Beyond are workshops and outhouses, all now gone and replaced by 1970s blocks of three-storey flats. In the far distance is the embankment of the Metropolitan Railway branch line and part of its bridge over the river.

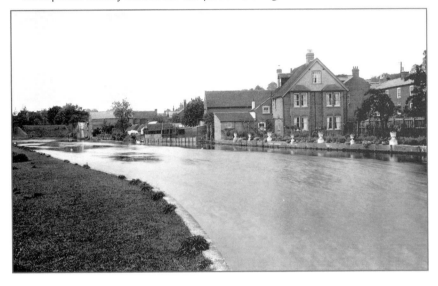

▼ **Chesham, The River Chess 1921** 70543

Further upstream, the photographer is looking back towards the outbuildings and workshops seen from the other direction in view 70542. The bank on the right, the Moor Lane side, is now more formal with a tarmac footpath; the trees have long gone. The boys would now be contemplating uninspiring blocks of three-storey flats on the Waterside or left bank.

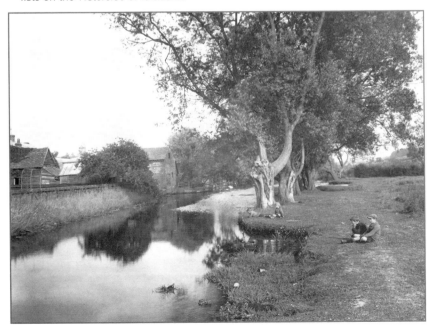

▲ **Chesham, Waterside Looking South from Lord's Mill 1906** 53654

Lord's Mill was one of the main watermills along the Chess south-east of Chesham and is behind the photographer who is looking over the Moor Lane bridge parapet. It fell into serious decay and was finally demolished in 1988, although its mill cottage survives as offices. Not only Lord's Mill went: all the buildings in this view also went in the 1950s and 1960s for road improvements and were replaced by undistinguished modern houses.

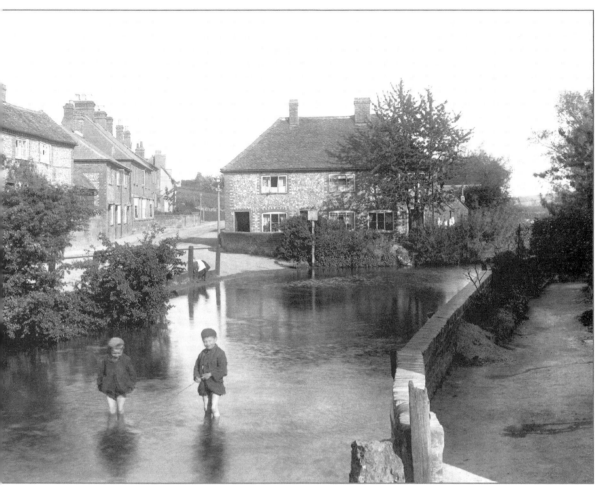

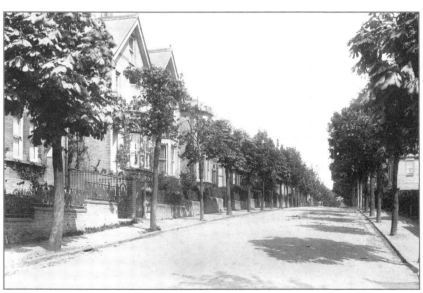

◄ **Chesham, Stanley Avenue 1906** 53652

Chesham also developed north of the town centre along the valleys and ridges in the late 19th and 20th centuries, the northern part being named Newtown. Broadly speaking the valley along Broad Street and Berkhamstead Road was for artisans and the working classes, the areas to east and west were middle class. The arrival of the Metropolitan Railway branch stimulated much of this growth and Stanley Avenue is typical of the latter, a tree-lined street of semi-detached suburban villas of the turn of the century.

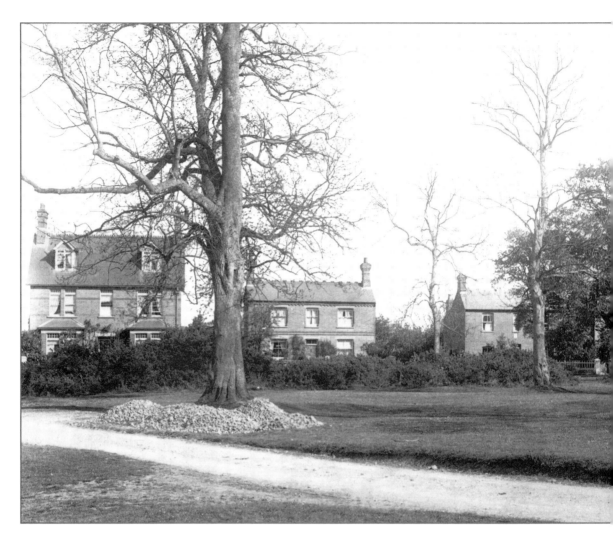

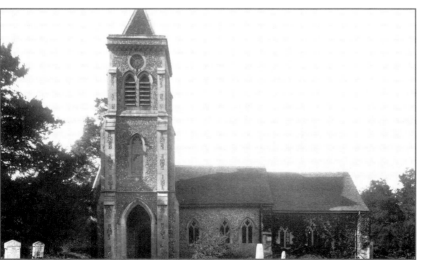

◄ **Chesham Bois
The Church 1906** 53657
The manor of Chesham
Bois, one of the three
manors of Chesham and
named after William de
Bosco or Boies who held
it around 1200, became
an independent parish
during the Middle Ages.
Its church has 14th
century elements although
was almost entirely rebuilt
in 1881. In 1884 the
tower was added and in
1911, after this view was
taken, the nave was
extended two further bays
to the left.

Along the Valley of the River Chess

◀ **Chesham Bois, The Common 1906** 53656
Our tour along the Chess valley towards
Rickmansworth starts on the hills south of the
valley in Chesham Bois, originally a scattered village
with the church at the north end and more houses
along the north side of Chesham Bois Common.
It expanded rapidly after the Metropolitan Railway
arrived at Chesham in 1889, indeed Star Cottage,
the second house from the left, is dated 1890.

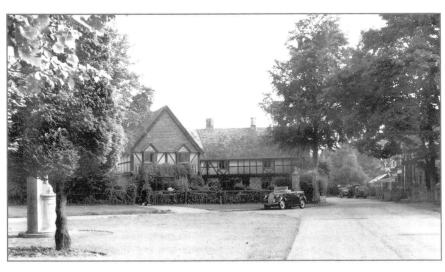

◀ **Chesham Bois, Anne's
Corner c1955** C693305
Back at Chesham Bois
Common, the common
acts partly as a buffer
between the village and
Amersham, although it
merges to the east and
west. The War Memorial
is partly hidden by the
left hand tree. In the
centre of the view is
Anne's Corner, a
picturesque house with
timber-framing to the
upper floor. On the east
side of Bois Lane are the
village shops, one with a
glass-roofed verandah.

Latimer, The Water Splash 1897 39693
Back in the Chess Valley we reach Latimer, a very pretty village with a triangular green and, uphill to the west, Latimer House. In fact much of the village was cleared in the 1750s to provide the grounds of Latimer House. Edward Blore rebuilt Latimer House in the 1830s, now offices for Price Waterhouse Cooper. In this view from the river bridge Latimer House can be glimpsed through the trees. The water splash is the weir which dams the park lake in which fisherman cast flies for trout.

▼ **Latimer, The Church 1897** 39694

Edward Blore also rebuilt the medieval chapel in brick in 1841. The church is away from the present centre of the village and relates more to Latimer Park. George Gilbert Scott, whose uncle had been rector, enlarged it in 1867, adding the apsidal chancel and the octagonal turret and spire. To the north is a housing estate that replaced the army buildings when the National Defence College, based on Latimer House, closed in the 1980s.

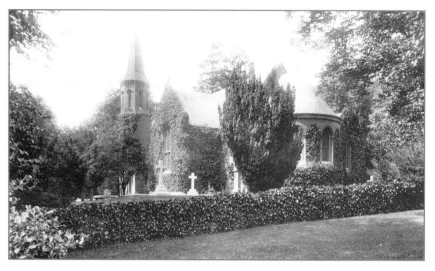

▼ **Latimer, The Village c1955** L504004

The village green complete with its old water pump is surrounded by 17th century timber-framed cottages, such as Foliots on the left, 19th century estate cottages and an old school. The second Lord Chesham, the son of the builder of Latimer House, was a Brigadier-General in the Boer War and the obelisk is a memorial to the men who served in that war. In front is the 1911 grave of Villebois, a horse wounded in the Boer War and brought back to England by Lord Chesham.

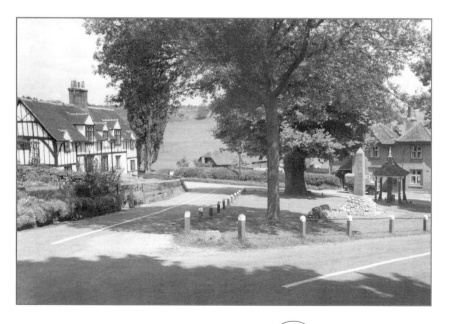

▲ **Chenies, The Manor House and Church 1903** 49313

Chenies, a mile downstream from Latimer, takes its name from the Cheyne family who held the manor from the 13th century until the 16th century when it passed, through the marriage in 1526 of the last of the Cheyne's, Anne Sapcote, to her third husband Sir John Russell. The Russells became earls and later dukes of Bedford and, although they had moved their seat to Woburn Abbey by the 18th century, the dukes continued to be buried in St Peter's Church in Chenies.

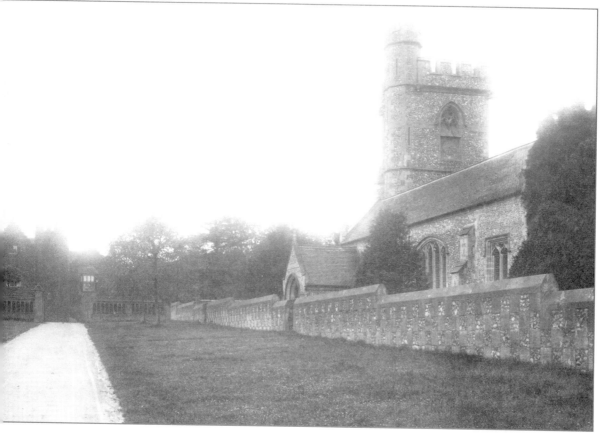

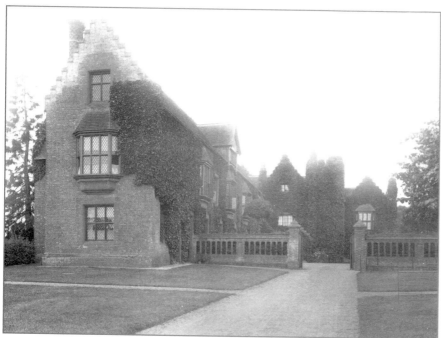

Chenies, The Old Manor House 1897
39680

In the late 15th century the Cheynes built the first part of the house, the hall, tower and the rest of the west range in the distance, an amorphous shape in brick under all the ivy, but far more interesting is the left hand or south range which were added by Russell before 1530. These were lodgings for distinguished guests who included Queen Elizabeth I in 1557. After having been a steward's house, the manor house was restored in the 1830s for Lord Wriothesley Russell. The lodgings range became five cottages.

▼ **Chenies, The Church 1897** 39681

Rebuilt in the 15th century, the church received the Bedford Chapel in 1556. Of this chapel only the archway into it from the church survives, the rest being rebuilt, enlarged and extended in the 1860s, 1880s and in 1906. Inside the chapel is a quite outstanding collection of tombs and effigies of the Russell family, ranging from Sir John, the first Earl of Bedford who died in 1554, to the 20th century Dukes of Bedford.

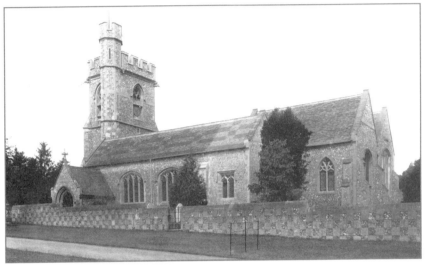

▼ **Chenies, The Green 1897** 49314

Looking east from the drive to the Manor House and Church, the village green in 1897 was all but submerged in tall trees. These have gone and there are much more modest trees in their place. The village is a mix of 17th century timber-framed cottages, and 1820s and 1840s to 1850s Bedford Estate cottages. Those in the distance are dated 1828 and Nos 28 and 29 on the left are timber-framed older cottages.

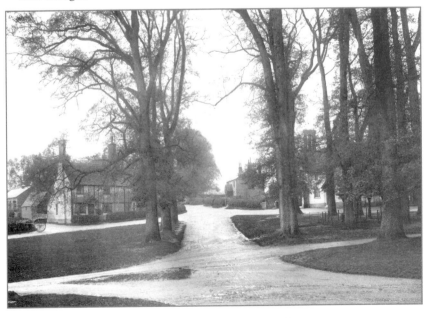

▲ **Chenies, The Village c1955** C609013

Moving down the lane away from the green there is a row of architecturally more mixed houses, some 1840s estate house, others older before the Estate went into picturesque Tudor mode. The green was a more self-consciously contrived piece of villagescape at the gates of the manor house. In this view there is an early 19th century Regency style rendered cottage with a verandah and, nearer the camera, a terrace of late 18th century brick cottages with Tudor estate styles in the distance, one dated 1846.

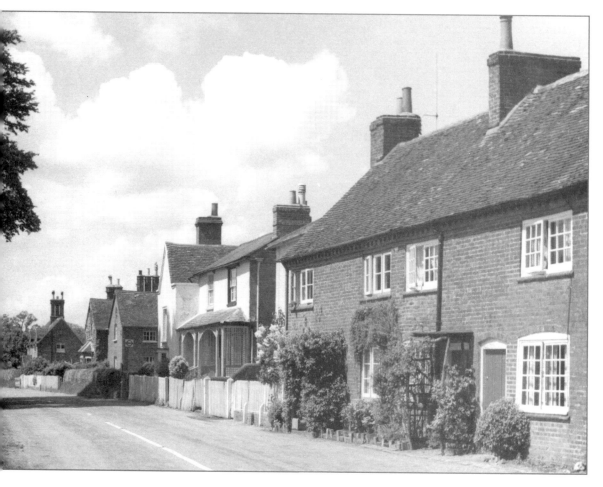

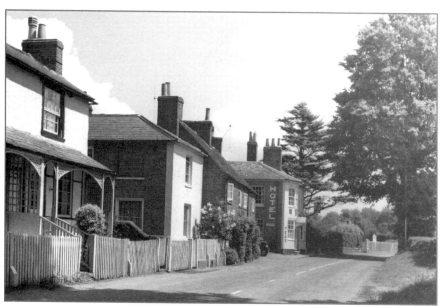

◀ **Chenies, The Village c1955** C609016
Looking from the opposite end of the group, we are looking towards the Red Lion, an early 19th century public house with attractive bay windows. Beyond, the railings and notice board belong to the Baptist Chapel, built in the 1770s and enlarged in 1799, a delightful hipped roofed building with galleries on three sides, lit by upper windows. The trees and hedge on the right have since been removed and a wide grass verge created.

Chorleywood, The Common 1903 49310
Crossing the Hertfordshire border our tour reaches Chorleywood, two miles on from Chenies and on the south side of the Chess valley. Chorleywood Common survived an attempt at enclosure and we see it here in its late 19th century gorse-covered state. The cricket ground is to the left in the distance, the Manor House in the centre and Christchurch spire to its right. At the right is the old rectory of 1870, now replaced by a 1960s one.

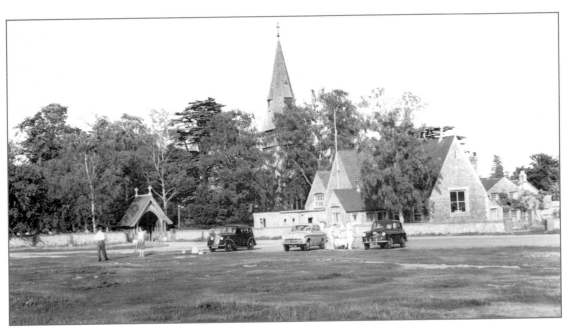

Chorleywood, The Church and School 1959 C226015
In the foreground is the church primary school, parts of which date back to 1853, now much extended. The church is the second one on the site, the first having been built in 1845, the year Chorleywood became a separate parish. This proved inadequate and in 1869 G E Street buttressed and raised the tower, added a spire and rebuilt the rest of the church we see now. The lychgate dates from 1920 and the car park is more extensive nowadays.

Rickmansworth

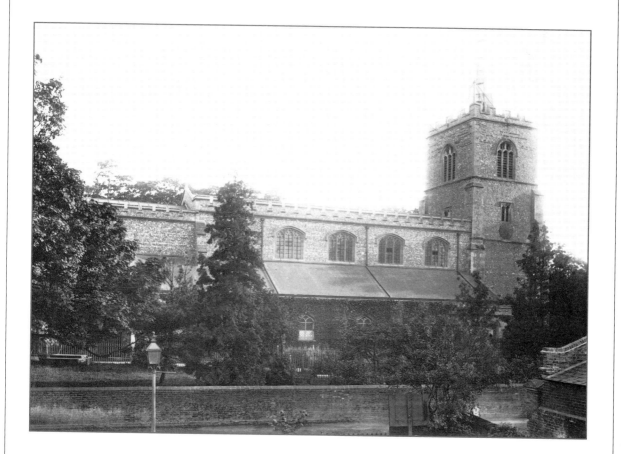

Rickmansworth
St Mary's Church 1897 39676
Taken from the upper storey of a cottage in Church Street, this
view of the north side of the church looks beguilingly medieval.
In fact the oldest part of the building is the tower which is a late
Gothic structure dated 1630, the aisles are in brick and remain
from an 1824 rebuild. The nave and chancel were rebuilt again
in flint in the 1880s by Sir Arthur Blomfield
with rainwater heads dated 1884.

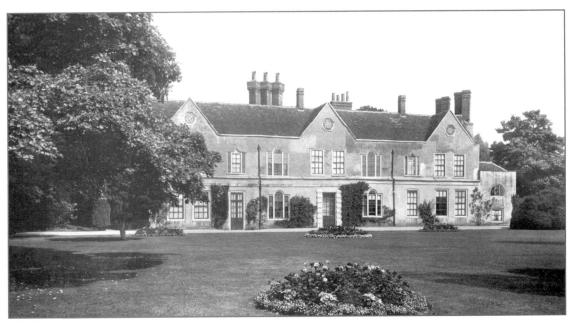

Rickmansworth, Bury House 1897 39684

West of the church and across a stream is The Bury, the manor house until 1741. At one time council offices it is now subdivided into houses and its grounds a public open space. This view is of the west front of this attractive house which, beneath its roughcast facade of about 1800, is a mid 17th century house with a late 16th century parlour wing; the three brick stacks probably relate to the Tudor great hall.

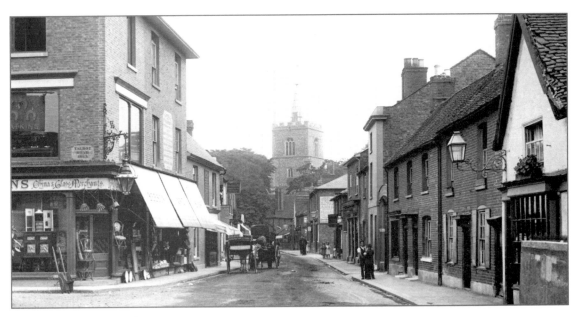

Rickmansworth, Church Street 1897 39675

Although Church Street has had much rebuilding in recent years it still retains its character and is one of the best streets in the old town. Beeson and Sons on the left occupy premises built in 1863 when Talbot Road was laid out. On the right, all the red brick cottages went about 1900 to be replaced by the buildings seen in view 49245. Much of the rest remains, including The Chequers pub on the left and the Kings Arms on the right. Beyond the Kings Arms is The Feathers, partly 16th century and enlarged in the 19th century.

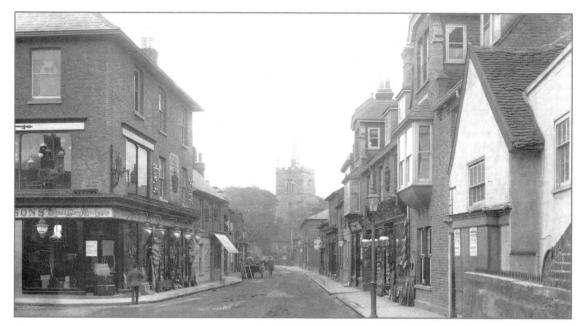

Rickmansworth, Church Street 1903 49245
By 1903 the tall, angular three-storey buildings on the right have appeared, busy with their oriel windows and buttressed top storeys. The rendered house on the right, with its 16th century gabled wing, fell into decline and was subsequently demolished. Beeson's, on the left, is still flourishing in 1903 but was rebuilt in the 1990s in approximate facsimile as offices named Talbot House, re-using the 'Talbot Road 1863' stone plaque street name.

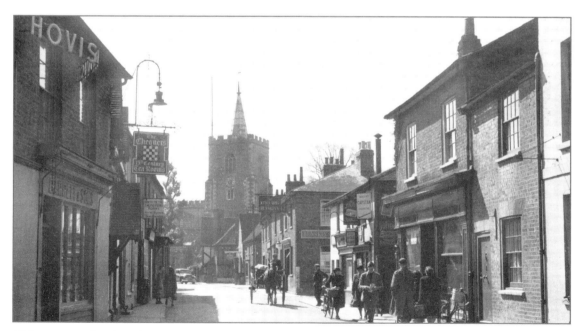

Rickmansworth, Church Street c1955 R33027
Nearer the church in this 1950s view, the King's Arms is in its last years as a pub, and is now converted to offices. The Chequers has the somewhat whimsical juxtaposition on its sign of '13th century' and 'tea rooms'. The timber-framing and big chimneys in the loom of the church tower is The Priory, a fascinating early 16th century timber-framed building built as a church house or marriage-feast house, although it has been a private house since about 1700.

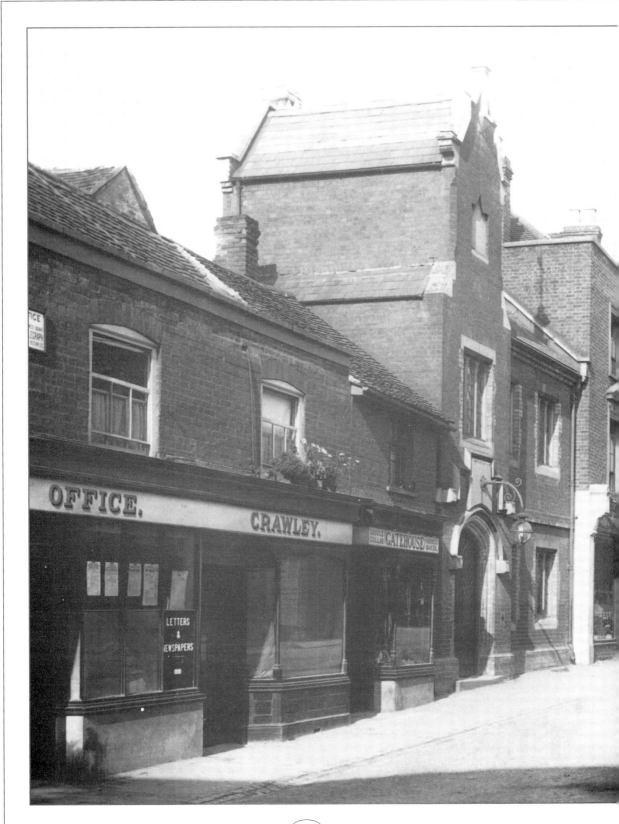

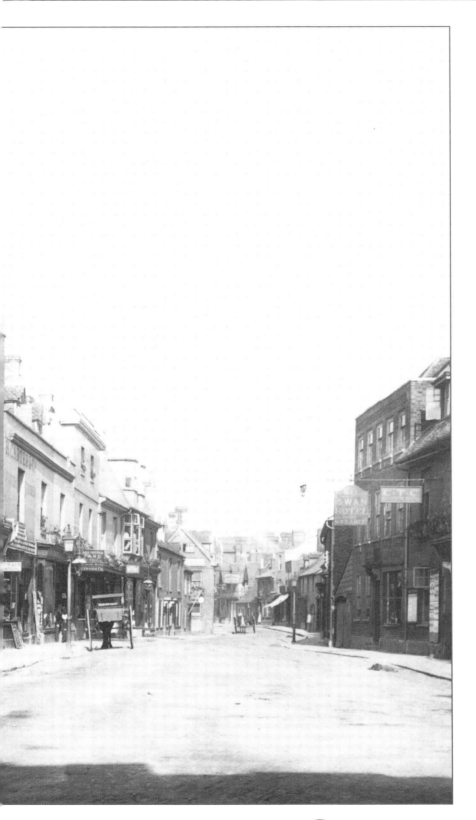

**Rickmansworth
High Street 1897**
39673
Most of the buildings
on the right have since
been rebuilt, while on
the left all up to the
three- storey brick
building with the
parapet, now the Abbey
National, have also
gone (and some
beyond). On the left is
Mrs Amelia Crawley's
linen drapery, fancy
repository, agent for
Pullar's Dye Works and
Post Office, rebuilt
about 1904. The odd
Gothic style building,
also now demolished, is
the old town hall built in
1869 on the site of
its predecessor.

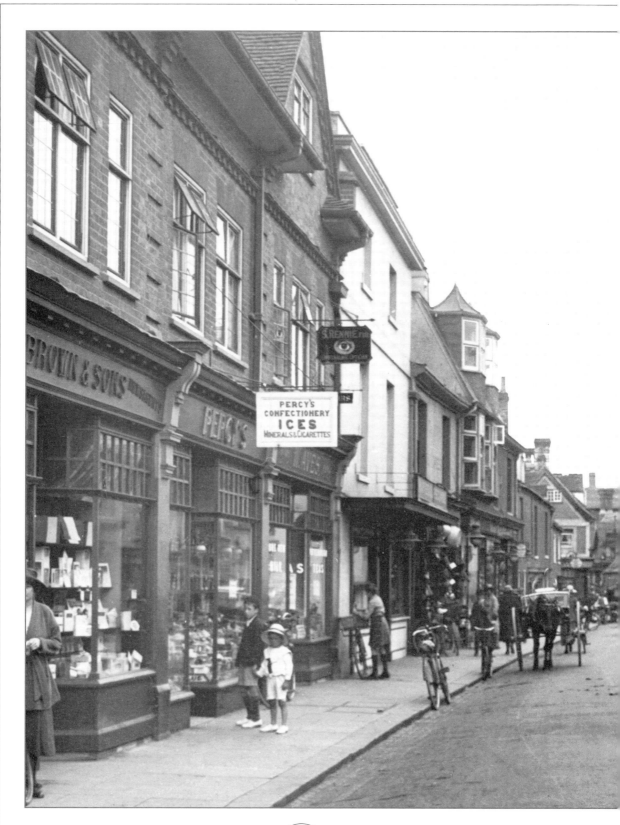

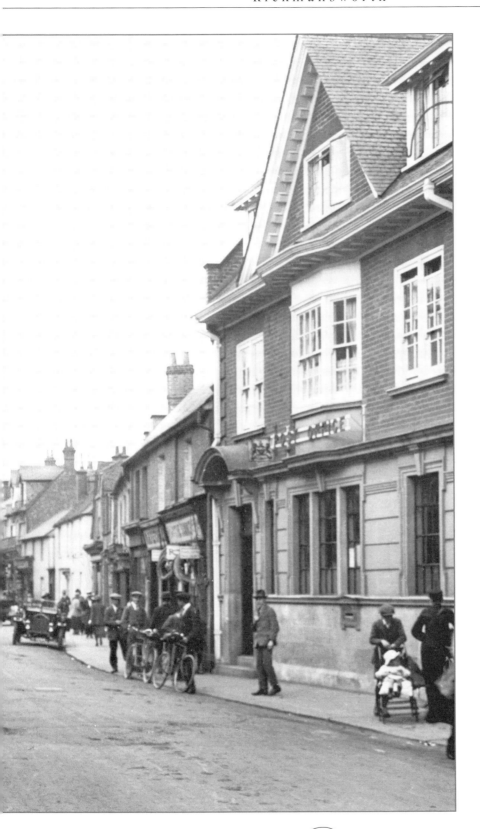

Rickmansworth High Street 1921
70498
The post office, that, in about 1910, replaced Mrs Crowley's premises, was in the style of Queen Anne. It is on the right with the modillioned cornice and pediment. It was demolished in turn in the 1960s. On the left the buildings beyond the present Nationwide were rebuilt before World War I and part is now The Pennsylvanian pub, a reference to William Penn, the founder of Pennsylvania who lived at Basing House in the High Street.

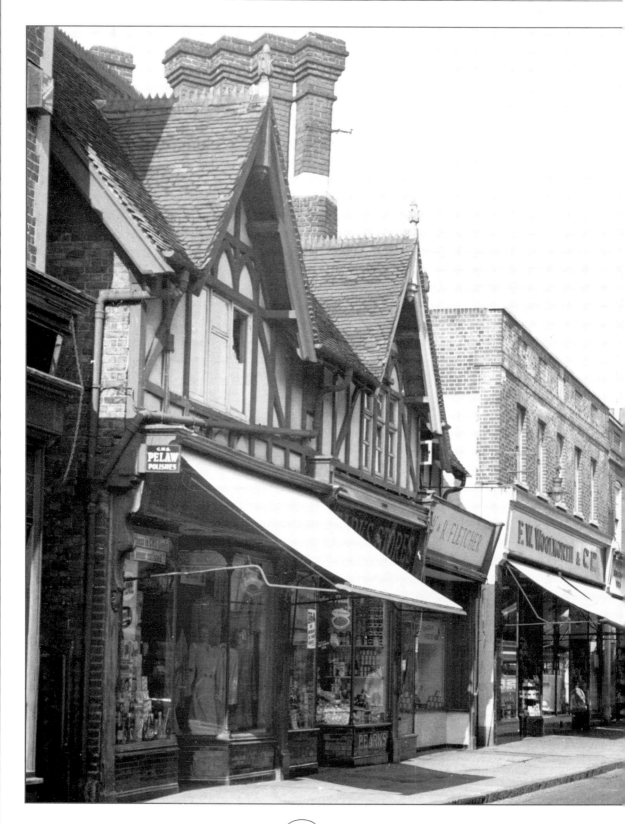

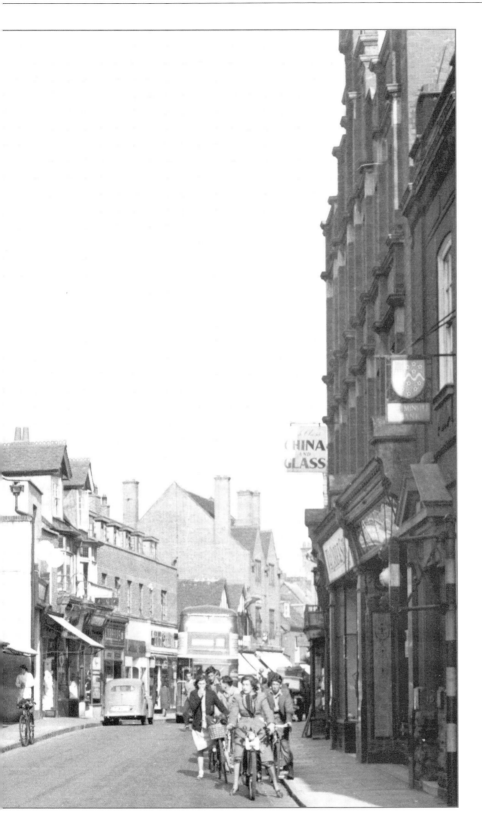

**Rickmansworth
High Street c1955**
R33028
In this view the photographer looks up High Street from the west, the opposite direction to that in the two earlier views. The elaborate diagonally-set chimneys of the Edwardian Tudor-style shops on the left, with their applied timber-framing, can be seen in the distance in view 70498. Woolworth's has a plaque reset in the parapet recording the building as a gift of 'John Fotherley, Esq, Lord of the Manor of Rickmansworth, Anno Domini 1812'.

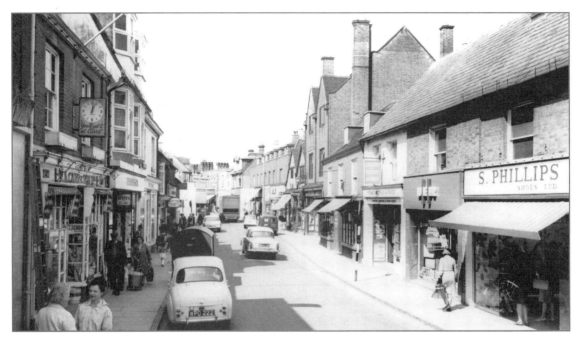

Rickmansworth, High Street c1965 R33065

This view again is taken from the east, with the Tudor-style chimneys in the distance and the tall two-gabled building on the right, W H Smith, in a simple Jacobean style dating from the 1920s. Carr and Sons 'You'll Get it at Carrs' on the left has since been rebuilt in approximate replica and is now a Sue Ryder charity shop.

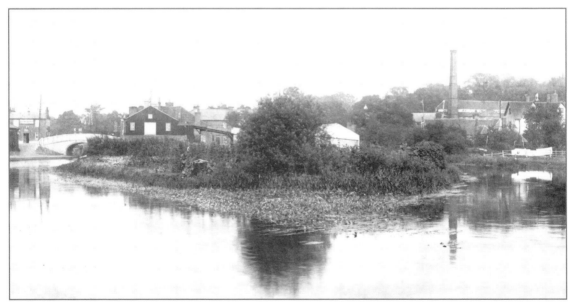

Rickmansworth, The Canal 1897 39698

This view from the tow-path looking towards Church Street is now very much changed. By 1796 the Grand Junction Canal passed through Rickmansworth on its way from Brentford on the Thames to Braunston. Here, utilising the course of the River Colne, the canal goes left of the island under the bridge. Batchworth Lock House beside it survives, but all else is changed: the island now sports a 1990s office block, Trinity Court, the far right has a riverside Tesco's. The mills, houses and chimney have all gone.

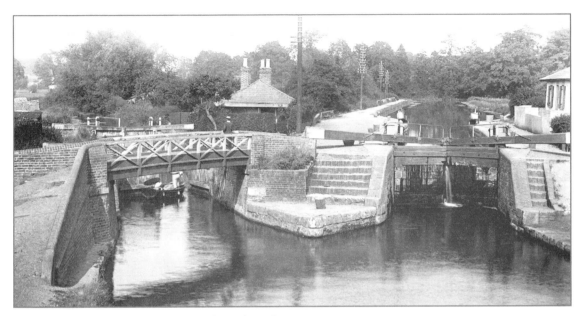

Rickmansworth, The Canal and Batchworth Lock 1897 39696
The main Grand Union Canal, as the Grand Junction Canal later became, is on the right. The left hand lock behind the footbridge, canalises the River Chess for a short distance from its junction with the River Colne. The central cottage has now gone, but there is a café instead. The lock keeper's cottage on the right was rebuilt in the 1960s, while out of sight on the left are the canal buildings used by the Batchworth Lock Canal Centre and the headquarters of the Rickmansworth Waterways Trust.

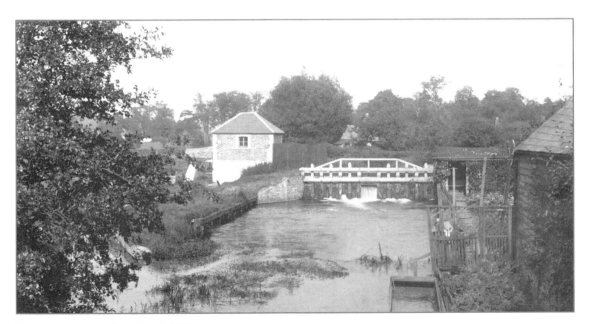

Rickmansworth, The Canal 1897 39695
The canalised stretch of the River Chess was opened in 1803 for Samuel Salter to ferry barrels between his Rickmansworth and Uxbridge breweries via the Grand Junction Canal. Now the canal winds past a builder's yard before petering out as the uncanalised River Chess, past the site of the old brewery and gas works. This builder's yard is beyond the small building on the left which still survives; the canal is beyond the weir which has been rebuilt recently and is crossed by a neat footbridge.

**Rickmansworth
Batchworth Lake
1921** 70511
Batchworth Lake is the
easternmost of a chain
of four lakes west of the
town and sandwiched
between the Grand
Union Canal and the
River Colne. They are
flooded gravel pits and
one, Stocker's Lake is a
nature reserve. In 1921
Batchworth Lake, being
nearest the town, was
already used for
recreation with rowing
boats and yachts.
Nowadays it is more
trendily named
Rickmansworth
Aquadrome, now
incorporating Bury Lake
which is used for
swimming and
Batchworth for water
sports, including sailing
and water skiing .

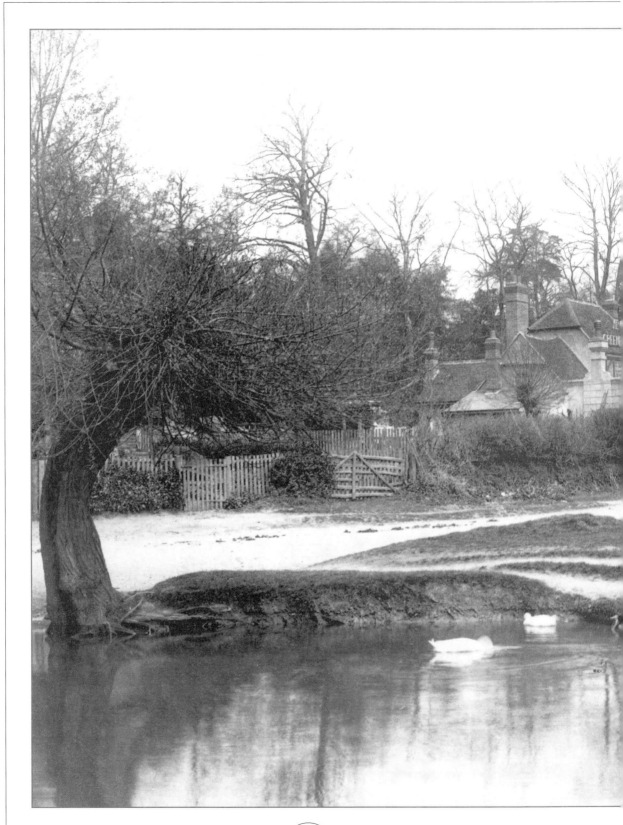

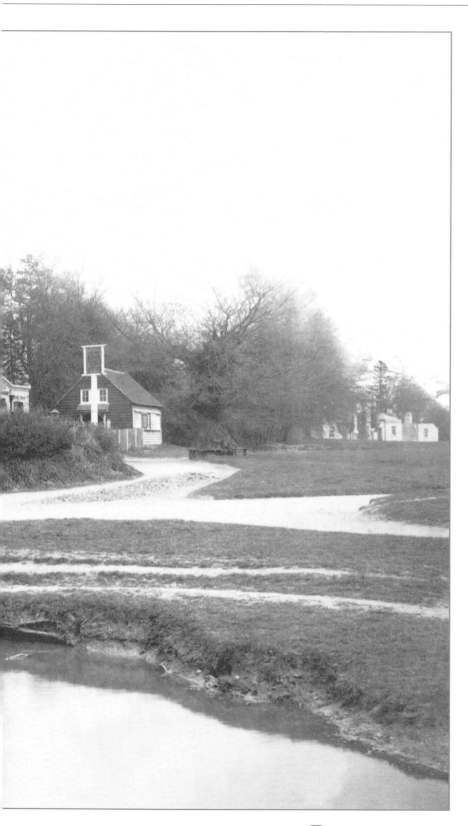

Rickmansworth Batchworth Heath 1903 49251
Across the Colne the main road to Pinner reaches Batchworth Heath, just before the old Middlesex county boundary. The Heath has been tamed since 1903 and the pond has gone, although a smaller one survives further away. Ye Olde Green Manne pub remains largely unchanged, even the gilded lettering survives. Away to the right are the south lodges to Moor Park, a pair of small lodges linked by a Tuscan Doric arch. From this viewpoint these are now hidden by young oaks.

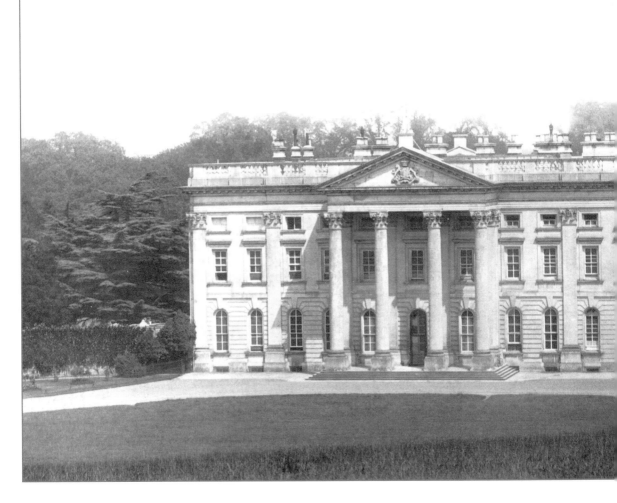

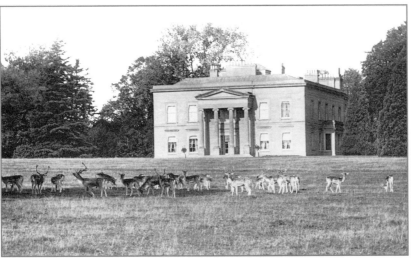

◀ **Rickmansworth, Bury Park Manor House 1897**
39687
Also known as Rickmansworth House, this four-square mansion dates from about 1820 and replaced a house of 1741 built for Henry Fotherley Whitfield, then Lord of the Manor. James Hayward, the new owner, apparently used French prisoners of war as labourers. Rickmansworth Park is now the site of the Royal Masonic School for Girls, built in the 1930s.

◄ Rickmansworth, Moor Park 1897

39686

Moor Park was built in the 1720s for the banker and South Sea Bubble profiteer Benjamin Styles. Set in a large landscaped park, reworked by Capability Brown in the 1750s, the east parts and north fringes of which went for housing in the 1930s, it was designed by Sir James Thornhill who had to sue Styles to get his fees paid. Thornhill was probably assisted by Giacomo Leoni to whom the house is often attributed. It apparently cost Styles £130,000, several millions in modern money. It is now a golf clubhouse.

▼ Rickmansworth, Croxley Green 1903 49255

This view looks south towards All Saints Church and shows how the tower and spire originally closed the vista well, although nowadays the church is hidden by high hedges and a fine cedar. On the right is the 18th century Artichoke pub which survives but with an added slated roof linking ground floor bay windows.

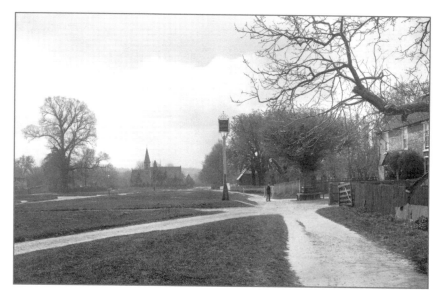

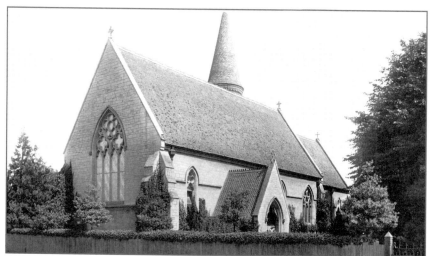

◄ Rickmansworth Croxley Green All Saints Church 1897

39689

This is an interesting view of All Saints at the south end of the Green. The church, built in 1872 to designs of one J Norton, is in a fairly routine design but with a circular turret and spire on the north or Green side. In 1907 the exciting architect Temple More added a nave, turning the old church into the north aisle. Moore used brick with stone bands and produced a most successful design.

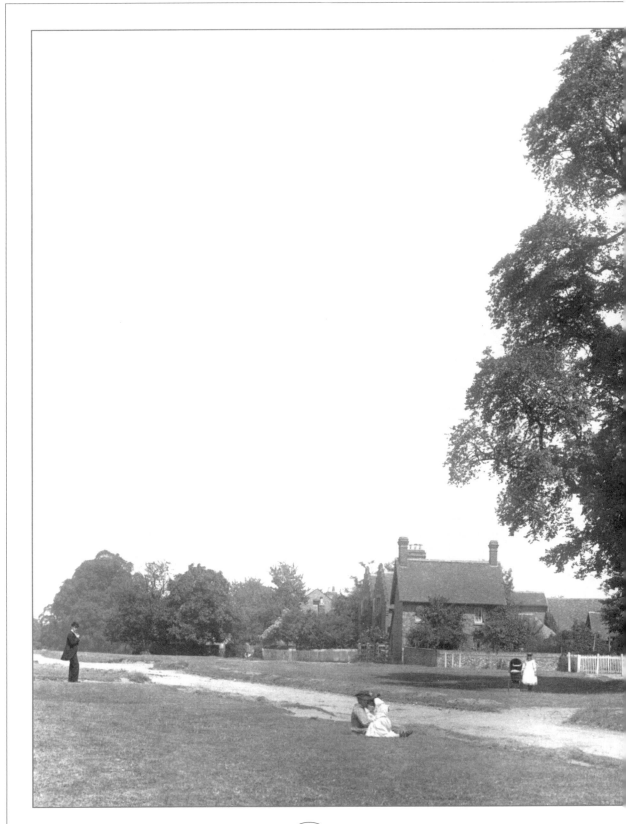

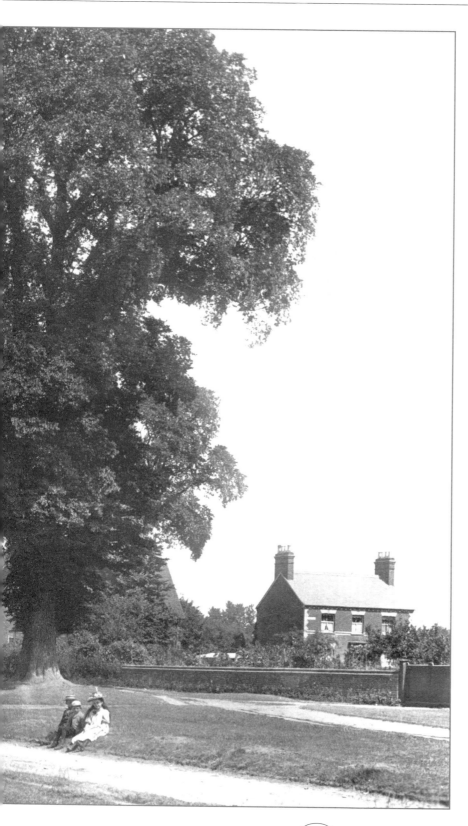

Rickmansworth Croxley Green 1897

39688

Croxley Green lies east of the River Chess, separated from Rickmansworth by the open space of Rickmansworth Park and Croxley Hall's woods. Originally a village of scattered houses beside a long, rectangular Green with a triangular north end, it spawned a commuter village in the 1930s based around Croxley Station. Earlier development shows in this view looking north-east up the Common with, to the right of the oak, Nos 3 and 7 New Road, a road laid out a few years earlier.

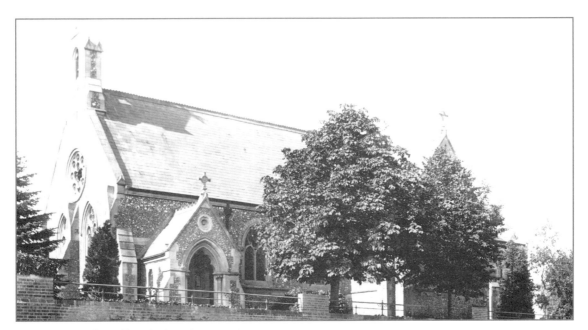

Rickmansworth, Mill End Church 1897 39682

The hamlet of Mill End, about a mile west of the centre of Rickmansworth, grew up along the main road to Uxbridge to serve a watermill and factories. Originally it was only served by a Congregational Chapel, but later acquired an Anglican church, St Peter the Apostle, seen here from a field, now a car park, and a Church of England primary school. The church is marred nowadays by a gruesome 1970s extension to form a church hall. The hamlet is now greatly expanded to the north and merges with Rickmansworth.

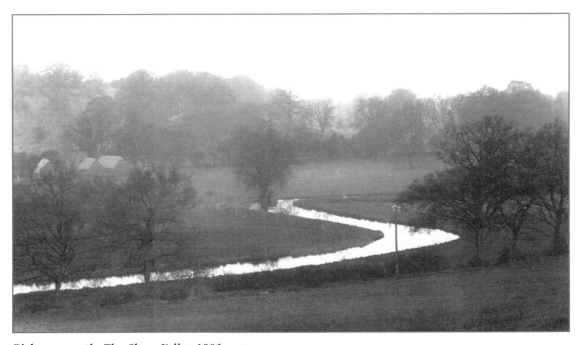

Rickmansworth, The Chess Valley 1903 49309

We finish with a view of the River Chess winding along the floor of its flat but narrow valley, through its Chiltern landscape towards Rickmansworth near Loudwater Farm, an area much changed since this view was taken.

Index

Frith Book Co Titles

www.francisfrith.co.uk

The Frith Book Company publishes over 100 new titles each year. A selection of those currently available are listed below. For latest catalogue please contact Frith Book Co.

Town Books 96pages, approx 100 photos. County and Themed Books 128pages, approx 150 photos (unless specified). All titles hardback laminated case and jacket except those indicated pb (paperback)

Title	ISBN	Price	Title	ISBN	Price
Amersham, Chesham & Rickmansworth (pb)	1-85937-340-2	£9.99	Dorset (pb)	1-85937-269-4	£9.99
Ancient Monuments & Stone Circles	1-85937-143-4	£17.99	Dorset Churches	1-85937-172-8	£17.99
Aylesbury (pb)	1-85937-227-9	£9.99	Dorset Coast (pb)	1-85937-299-6	£9.99
Bakewell	1-85937-113-2	£12.99	Dorset Living Memories	1-85937-210-4	£14.99
Barnstaple (pb)	1-85937-300-3	£9.99	Down the Severn	1-85937-118-3	£14.99
Bath (pb)	1-85937419-0	£9.99	Down the Thames (pb)	1-85937-278-3	£9.99
Bedford (pb)	1-85937-205-8	£9.99	Down the Trent	1-85937-311-9	£14.99
Belfast (pb)	1-85937-303-8	£9.99	Dublin (pb)	1-85937-231-7	£9.99
Berkshire (pb)	1-85937-191-4	£9.99	East Anglia (pb)	1-85937-265-1	£9.99
Berkshire Churches	1-85937-170-1	£17.99	East London	1-85937-080-2	£14.99
Blackpool (pb)	1-85937-382-8	£9.99	East Sussex	1-85937-130-2	£14.99
Bognor Regis (pb)	1-85937-431-x	£9.99	Eastbourne	1-85937-061-6	£12.99
Bournemouth	1-85937-067-5	£12.99	Edinburgh (pb)	1-85937-193-0	£8.99
Bradford (pb)	1-85937-204-x	£9.99	England in the 1880's	1-85937-331-3	£17.99
Brighton & Hove(pb)	1-85937-192-2	£8.99	English Castles (pb)	1-85937-434-4	£9.99
Bristol (pb)	1-85937-264-3	£9.99	English Country Houses	1-85937-161-2	£17.99
British Life A Century Ago (pb)	1-85937-213-9	£9.99	Essex (pb)	1-85937-270-8	£9.99
Buckinghamshire (pb)	1-85937-200-7	£9.99	Exeter	1-85937-126-4	£12.99
Camberley (pb)	1-85937-222-8	£9.99	Exmoor	1-85937-132-9	£14.99
Cambridge (pb)	1-85937-422-0	£9.99	Falmouth	1-85937-066-7	£12.99
Cambridgeshire (pb)	1-85937-420-4	£9.99	Folkestone (pb)	1-85937-124-8	£9.99
Canals & Waterways (pb)	1-85937-291-0	£9.99	Glasgow (pb)	1-85937-190-6	£9.99
Canterbury Cathedral (pb)	1-85937-179-5	£9.99	Gloucestershire	1-85937-102-7	£14.99
Cardiff (pb)	1-85937-093-4	£9.99	Great Yarmouth (pb)	1-85937-426-3	£9.99
Carmarthenshire	1-85937-216-3	£14.99	Greater Manchester (pb)	1-85937-266-x	£9.99
Chelmsford (pb)	1-85937-310-0	£9.99	Guildford (pb)	1-85937-410-7	£9.99
Cheltenham (pb)	1-85937-095-0	£9.99	Hampshire (pb)	1-85937-279-1	£9.99
Cheshire (pb)	1-85937-271-6	£9.99	Hampshire Churches (pb)	1-85937-207-4	£9.99
Chester	1-85937-090-x	£12.99	Harrogate	1-85937-423-9	£9.99
Chesterfield	1-85937-378-x	£9.99	Hastings & Bexhill (pb)	1-85937-131-0	£9.99
Chichester (pb)	1-85937-228-7	£9.99	Heart of Lancashire (pb)	1-85937-197-3	£9.99
Colchester (pb)	1-85937-188-4	£8.99	Helston (pb)	1-85937-214-7	£9.99
Cornish Coast	1-85937-163-9	£14.99	Hereford (pb)	1-85937-175-2	£9.99
Cornwall (pb)	1-85937-229-5	£9.99	Herefordshire	1-85937-174-4	£14.99
Cornwall Living Memories	1-85937-248-1	£14.99	Hertfordshire (pb)	1-85937-247-3	£9.99
Cotswolds (pb)	1-85937-230-9	£9.99	Horsham (pb)	1-85937-432-8	£9.99
Cotswolds Living Memories	1-85937-255-4	£14.99	Humberside	1-85937-215-5	£14.99
County Durham	1-85937-123-x	£14.99	Hythe, Romney Marsh & Ashford	1-85937-256-2	£9.99
Croydon Living Memories	1-85937-162-0	£9.99	Ipswich (pb)	1-85937-424-7	£9.99
Cumbria	1-85937-101-9	£14.99	Ireland (pb)	1-85937-181-7	£9.99
Dartmoor	1-85937-145-0	£14.99	Isle of Man (pb)	1-85937-268-6	£9.99
Derby (pb)	1-85937-367-4	£9.99	Isles of Scilly	1-85937-136-1	£14.99
Derbyshire (pb)	1-85937-196-5	£9.99	Isle of Wight (pb)	1-85937-429-8	£9.99
Devon (pb)	1-85937-297-x	£9.99	Isle of Wight Living Memories	1-85937-304-6	£14.99

Available from your local bookshop or from the publisher

Frith Book Co Titles (continued)

Kent (pb)	1-85937-189-2	£9.99	Sheffield, South Yorks (pb)	1-85937-267-8	£9.99
Kent Living Memories	1-85937-125-6	£14.99	Shrewsbury (pb)	1-85937-325-9	£9.99
Lake District (pb)	1-85937-275-9	£9.99	Shropshire (pb)	1-85937-326-7	£9.99
Lancaster, Morecambe & Heysham (pb)	1-85937-233-3	£9.99	Somerset	1-85937-153-1	£14.99
Leeds (pb)	1-85937-202-3	£9.99	South Devon Coast	1-85937-107-8	£14.99
Leicester	1-85937-073-x	£12.99	South Devon Living Memories	1-85937-168-x	£14.99
Leicestershire (pb)	1-85937-185-x	£9.99	South Hams	1-85937-220-1	£14.99
Lighthouses	1-85937-257-0	£17.99	Southampton (pb)	1-85937-427-1	£9.99
Lincolnshire (pb)	1-85937-433-6	£9.99	Southport (pb)	1-85937-425-5	£9.99
Liverpool & Merseyside (pb)	1-85937-234-1	£9.99	Staffordshire	1-85937-047-0	£12.99
London (pb)	1-85937-183-3	£9.99	Stratford upon Avon	1-85937-098-5	£12.99
Ludlow (pb)	1-85937-176-0	£9.99	Suffolk (pb)	1-85937-221-x	£9.99
Luton (pb)	1-85937-235-x	£9.99	Suffolk Coast	1-85937-259-7	£14.99
Maidstone	1-85937-056-x	£14.99	Surrey (pb)	1-85937-240-6	£9.99
Manchester (pb)	1-85937-198-1	£9.99	Sussex (pb)	1-85937-184-1	£9.99
Middlesex	1-85937-158-2	£14.99	Swansea (pb)	1-85937-167-1	£9.99
New Forest	1-85937-128-0	£14.99	Tees Valley & Cleveland	1-85937-211-2	£14.99
Newark (pb)	1-85937-366-6	£9.99	Thanet (pb)	1-85937-116-7	£9.99
Newport, Wales (pb)	1-85937-258-9	£9.99	Tiverton (pb)	1-85937-178-7	£9.99
Newquay (pb)	1-85937-421-2	£9.99	Torbay	1-85937-063-2	£12.99
Norfolk (pb)	1-85937-195-7	£9.99	Truro	1-85937-147-7	£12.99
Norfolk Living Memories	1-85937-217-1	£14.99	Victorian and Edwardian Cornwall	1-85937-252-x	£14.99
Northamptonshire	1-85937-150-7	£14.99	Victorian & Edwardian Devon	1-85937-253-8	£14.99
Northumberland Tyne & Wear (pb)	1-85937-281-3	£9.99	Victorian & Edwardian Kent	1-85937-149-3	£14.99
North Devon Coast	1-85937-146-9	£14.99	Vic & Ed Maritime Album	1-85937-144-2	£17.99
North Devon Living Memories	1-85937-261-9	£14.99	Victorian and Edwardian Sussex	1-85937-157-4	£14.99
North London	1-85937-206-6	£14.99	Victorian & Edwardian Yorkshire	1-85937-154-x	£14.99
North Wales (pb)	1-85937-298-8	£9.99	Victorian Seaside	1-85937-159-0	£17.99
North Yorkshire (pb)	1-85937-236-8	£9.99	Villages of Devon (pb)	1-85937-293-7	£9.99
Norwich (pb)	1-85937-194-9	£8.99	Villages of Kent (pb)	1-85937-294-5	£9.99
Nottingham (pb)	1-85937-324-0	£9.99	Villages of Sussex (pb)	1-85937-295-3	£9.99
Nottinghamshire (pb)	1-85937-187-6	£9.99	Warwickshire (pb)	1-85937-203-1	£9.99
Oxford (pb)	1-85937-411-5	£9.99	Welsh Castles (pb)	1-85937-322-4	£9.99
Oxfordshire (pb)	1-85937-430-1	£9.99	West Midlands (pb)	1-85937-289-9	£9.99
Peak District (pb)	1-85937-280-5	£9.99	West Sussex	1-85937-148-5	£14.99
Penzance	1-85937-069-1	£12.99	West Yorkshire (pb)	1-85937-201-5	£9.99
Peterborough (pb)	1-85937-219-8	£9.99	Weymouth (pb)	1-85937-209-0	£9.99
Piers	1-85937-237-6	£17.99	Wiltshire (pb)	1-85937-277-5	£9.99
Plymouth	1-85937-119-1	£12.99	Wiltshire Churches (pb)	1-85937-171-x	£9.99
Poole & Sandbanks (pb)	1-85937-251-1	£9.99	Wiltshire Living Memories	1-85937-245-7	£14.99
Preston (pb)	1-85937-212-0	£9.99	Winchester (pb)	1-85937-428-x	£9.99
Reading (pb)	1-85937-238-4	£9.99	Windmills & Watermills	1-85937-242-2	£17.99
Romford (pb)	1-85937-319-4	£9.99	Worcester (pb)	1-85937-165-5	£9.99
Salisbury (pb)	1-85937-239-2	£9.99	Worcestershire	1-85937-152-3	£14.99
Scarborough (pb)	1-85937-379-8	£9.99	York (pb)	1-85937-199-x	£9.99
St ALbans (pb)	1-85937-341-0	£9.99	Yorkshire (pb)	1-85937-186-8	£9.99
St Ives (pb)	1-85937415-8	£9.99	Yorkshire Living Memories	1-85937-166-3	£14.99
Scotland (pb)	1-85937-182-5	£9.99			
Scottish Castles (pb)	1-85937-323-2	£9.99			
Sevenoaks & Tunbridge	1-85937-057-8	£12.99			

See Frith books on the internet www.francisfrith.co.uk

FRITH PRODUCTS & SERVICES

Francis Frith would doubtless be pleased to know that the pioneering publishing venture he started in 1860 still continues today. A hundred and forty years later, The Francis Frith Collection continues in the same innovative tradition and is now one of the foremost publishers of vintage photographs in the world. Some of the current activities include:

Interior Decoration

Today Frith's photographs can be seen framed and as giant wall murals in thousands of pubs, restaurants, hotels, banks, retail stores and other public buildings throughout the country. In every case they enhance the unique local atmosphere of the places they depict and provide reminders of gentler days in an increasingly busy and frenetic world.

Product Promotions

Frith products are used by many major companies to promote the sales of their own products or to reinforce their own history and heritage. Frith promotions have been used by Hovis bread, Courage beers, Scots Porage Oats, Colman's mustard, Cadbury's foods, Mellow Birds coffee, Dunhill pipe tobacco, Guinness, and Bulmer's Cider.

Genealogy and Family History

As the interest in family history and roots grows world-wide, more and more people are turning to Frith's photographs of Great Britain for images of the towns, villages and streets where their ancestors lived; and, of course, photographs of the churches and chapels where their ancestors were christened, married and buried are an essential part of every genealogy tree and family album.

Frith Products

All Frith photographs are available Framed or just as Mounted Prints and Posters (size 23 x 16 inches). These may be ordered from the address below. From time to time other products - Address Books, Calendars, Table Mats, etc - are available.

The Internet

Already twenty thousand Frith photographs can be viewed and purchased on the internet through the Frith websites and a myriad of partner sites.

For more detailed information on Frith companies and products, look at these sites:

www.francisfrith.co.uk
www.francisfrith.com
(for North American visitors)

See the complete list of Frith Books at:

www.francisfrith.co.uk

This web site is regularly updated with the latest list of publications from the Frith Book Company. If you wish to buy books relating to another part of the country that your local bookshop does not stock, you may purchase on-line.

For further information, trade, or author enquiries please contact us at the address below:
The Francis Frith Collection, Frith's Barn, Teffont, Salisbury, Wiltshire, England SP3 5QP.
Tel: +44 (0)1722 716 376 Fax: +44 (0)1722 716 881 Email: sales@francisfrith.co.uk

See Frith books on the internet www.francisfrith.co.uk

TO RECEIVE YOUR FREE MOUNTED PRINT

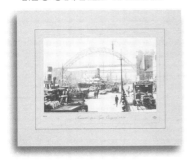

Mounted Print
Overall size 14 x 11 inches

Cut out this Voucher and return it with your remittance for £1.95 to cover postage and handling, to UK addresses. For overseas addresses please include £4.00 post and handling. Choose any photograph included in this book. Your SEPIA print will be A4 in size, and mounted in a cream mount with burgundy rule line, overall size 14 x 11 inches.

Order additional Mounted Prints at HALF PRICE (only £7.49 each*)

If there are further pictures you would like to order, possibly as gifts for friends and family, purchase them at half price (no additional postage and handling required).

Have your Mounted Prints framed*

For an additional £14.95 per print you can have your chosen Mounted Print framed in an elegant polished wood and gilt moulding, overall size 16 x 13 inches (no additional postage and handling required).

*** IMPORTANT!**
These special prices are only available if ordered using the original voucher on this page (no copies permitted) and at the same time as your free Mounted Print, for delivery to the same address

Frith Collectors' Guild

From time to time we publish a magazine of news and stories about Frith photographs and further special offers of Frith products. If you would like 12 months FREE membership, please return this form.

Send completed forms to:
The Francis Frith Collection, Frith's Barn, Teffont, Salisbury, Wiltshire SP3 5QP

Voucher for FREE and Reduced Price Frith Prints

Picture no.	Page number	Qty	Mounted @ £7.49	Framed + £14.95	Total Cost
		1	Free of charge*	£	£
			£7.49	£	£
			£7.49	£	£
			£7.49	£	£
			£7.49	£	£
			£7.49	£	£

Please allow 28 days for delivery	*** Post & handling**	**£1.95**
Book Title	**Total Order Cost**	£

Please do not photocopy this voucher. Only the original is valid, so please cut it out and return it to us.

I enclose a cheque / postal order for £
made payable to 'The Francis Frith Collection'
OR please debit my Mastercard / Visa / Switch / Amex card
(credit cards please on all overseas orders)

Number .

Issue No(Switch only)Valid from (Amex/Switch)

Expires Signature

Name Mr/Mrs/Ms .

Address .

. .

. Postcode

Daytime Tel No . Valid to 31/12/02

The Francis Frith Collectors' Guild

Please enrol me as a member for 12 months free of charge.

Name Mr/Mrs/Ms .

Address .

. .

. Postcode

Would you like to find out more about Francis Frith?

We have recently recruited some entertaining speakers who are happy to visit local groups, clubs and societies to give an illustrated talk documenting Frith's travels and photographs. If you are a member of such a group and are interested in hosting a
presentation, we would love to hear from you.

Our speakers bring with them a small selection of our local town and county books, together with sample prints. They are happy to take orders. A small proportion of the order value is donated to the group who have hosted the presentation. The talks are therefore an excellent way of fundraising for small groups and societies.

Can you help us with information about any of the Frith photographs in this book?

We are gradually compiling an historical record for each of the photographs in the Frith archive. It is always fascinating to find out the names of the people shown in the pictures, as well as insights into the shops, buildings and other features depicted.

If you recognize anyone in the photographs in this book, or if you have information not already included in the author's caption, do let us know. We would love to hear from you, and will try to publish it in future books or articles.

Our production team

Frith books are produced by a small dedicated team at offices in the converted Grade II listed 18th-century barn at Teffont near Salisbury, illustrated above. Most have worked with the Frith Collection for many years. All have in common one quality: they have a passion for the Frith Collection. The team is constantly expanding, but currently includes:

Jason Buck, John Buck, Douglas Burns, Heather Crisp, Isobel Hall,
Rob Hames, Hazel Heaton, Peter Horne, James Kinnear, Tina Leary,
Eliza Sackett, Terence Sackett, Sandra Sanger, Shelley Tolcher, Susanna Walker,
Clive Wathen and Jenny Wathen.